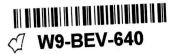
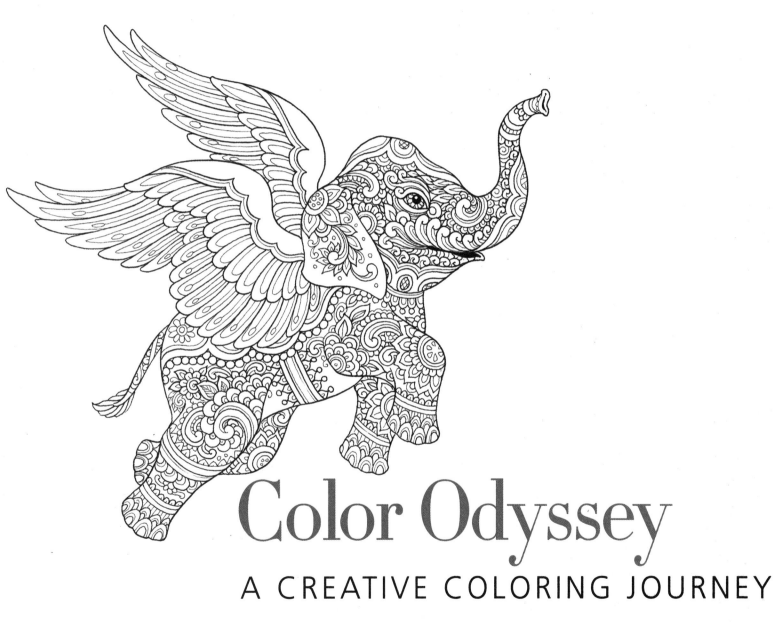

Color Odyssey

A CREATIVE COLORING JOURNEY

CHRIS GARVER

Get Creative 6
NEW YORK

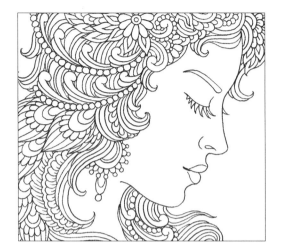

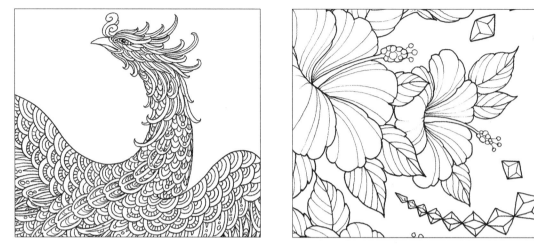

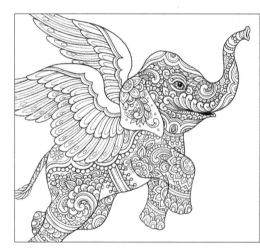

Journey into the world of Chris Garver's art.

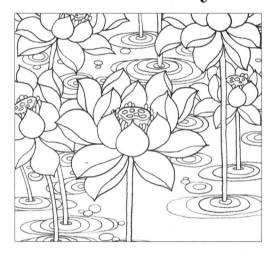

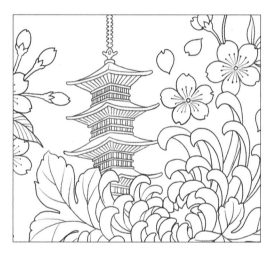

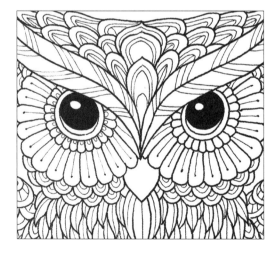

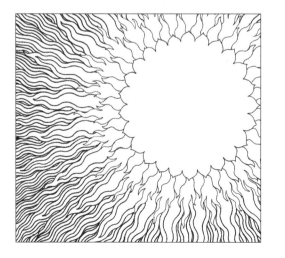

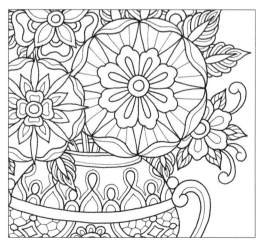

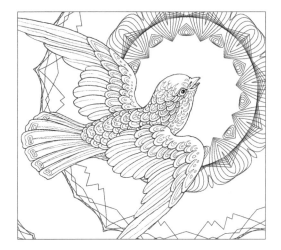

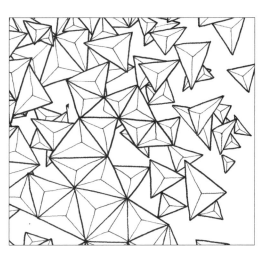

➼ To my mother, Wilhelmina, and my daughter, Nyarah

Let the color odyssey begin...

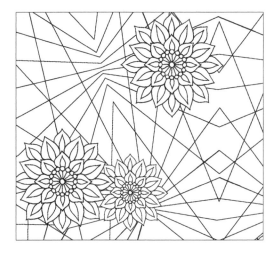

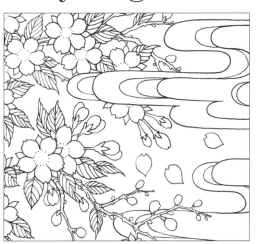

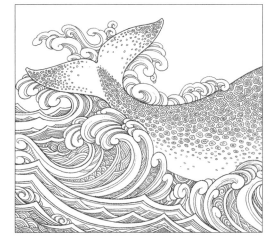

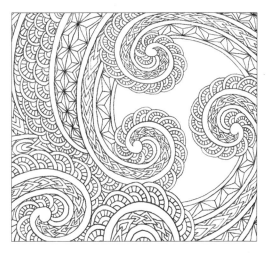

INTRODUCTION

As I was working on this book, I kept thinking that coloring is fun no matter who you are. That's just how it is. You get to use your own creativity in picking colors, and it can be really relaxing to physically do it instead of just sitting back and watching TV.

People sometimes forget that doing things just for fun is rewarding and important. It's like getting back in touch with your inner child by doing stuff you enjoyed when you were little. It helps you remember what it was like to just be happy. But you mature as you get older, so your taste in imagery is different from what it was when you were a kid. You can still appreciate those things, but to enjoy coloring as an adult, the visuals have to be something that makes sense for who you are now.

I'm a bit of a workaholic, and creating the art for this book was a lot different from the way I normally work. When I am doing a piece of art for myself, I work at an idea until it is totally complete. So if it's a painting, for example, I start with a sketch and revise it until I am happy with that. Then I move on to actually painting. But for this—a collection of line art—the idea is that someone else finishes it. I'm interested in seeing how people color it in; I know it will be totally different from how I imagine it and unique to each person who picks up a pen or a colored pencil to work on it.

—CHRIS GARVER

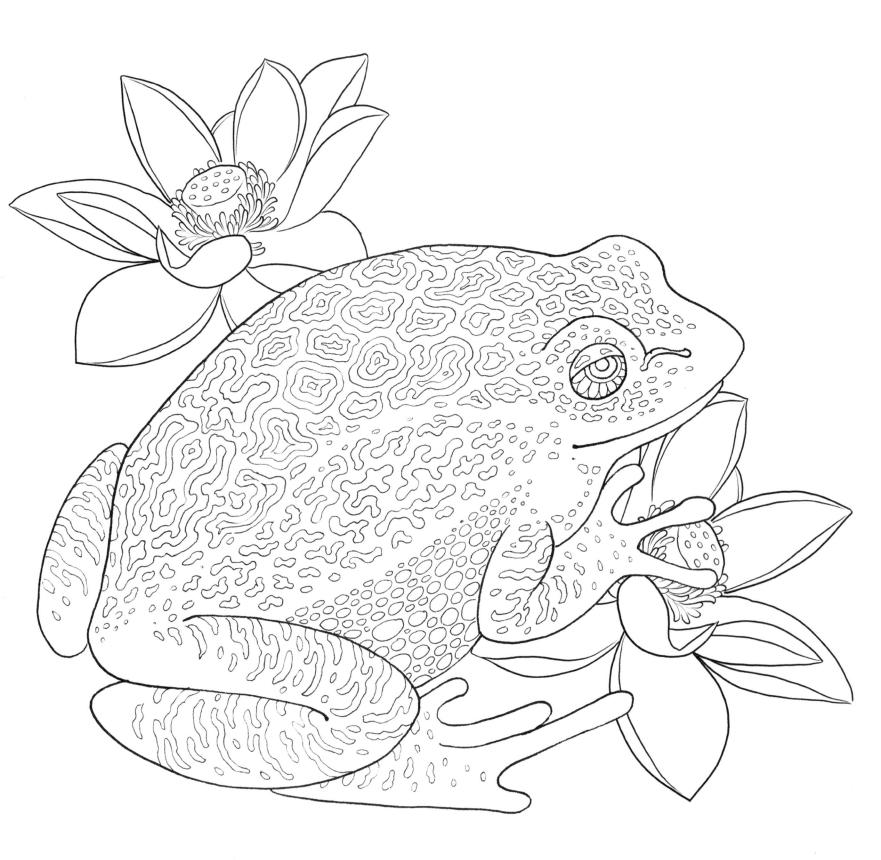

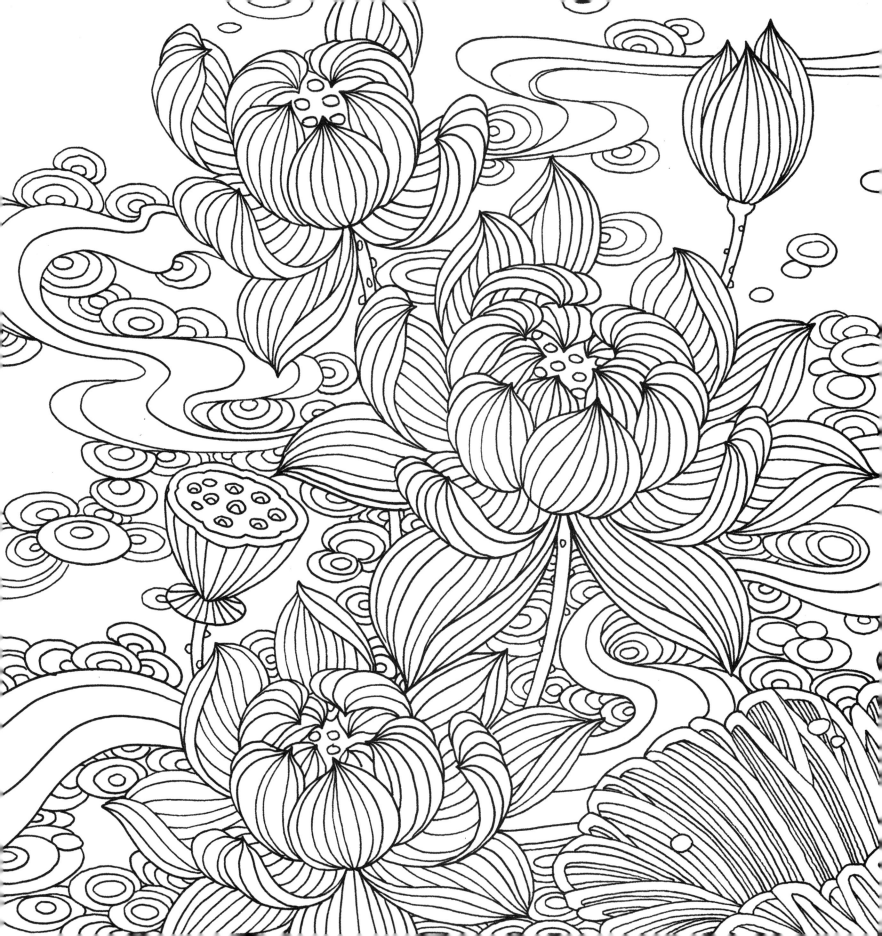

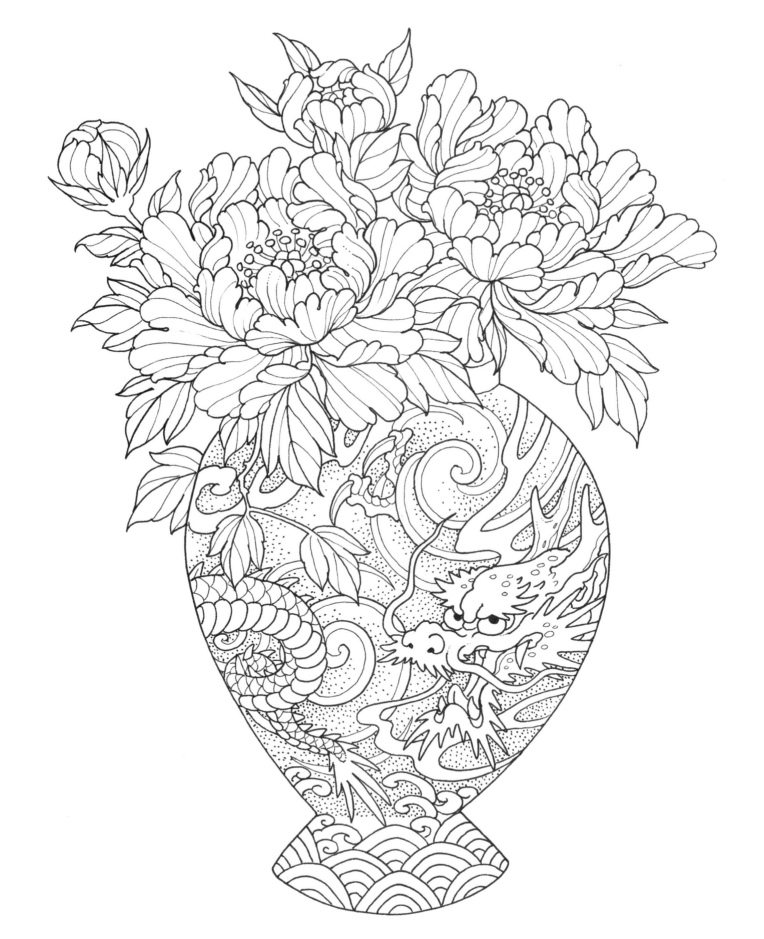

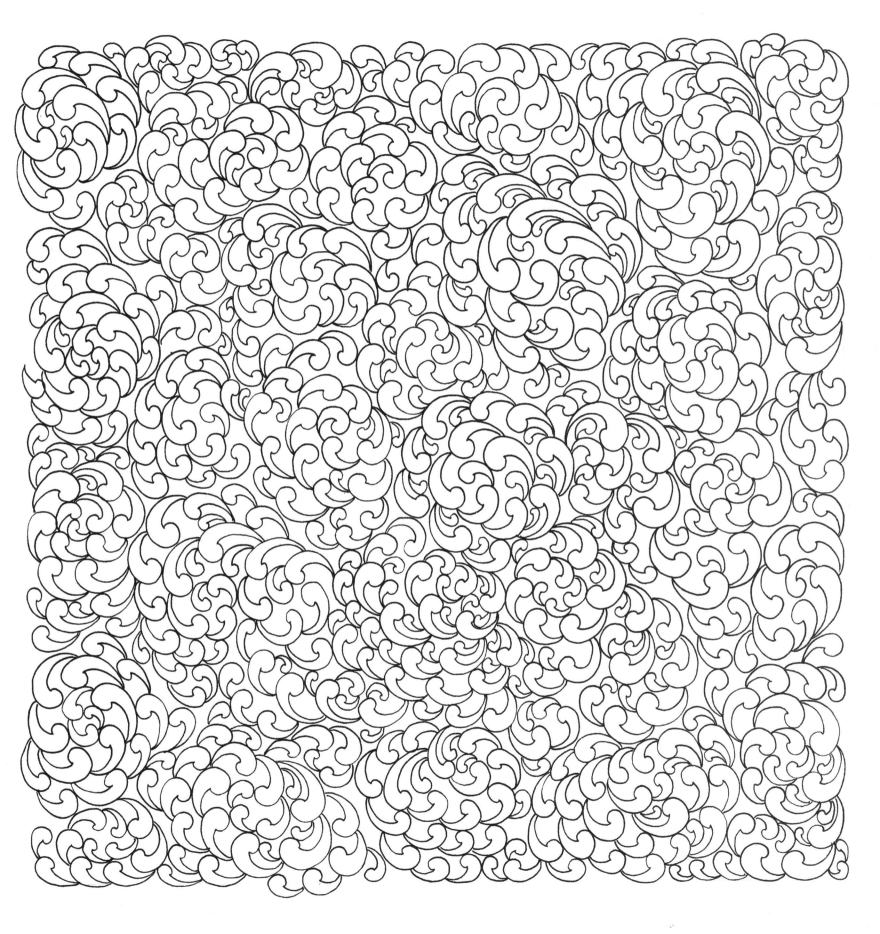

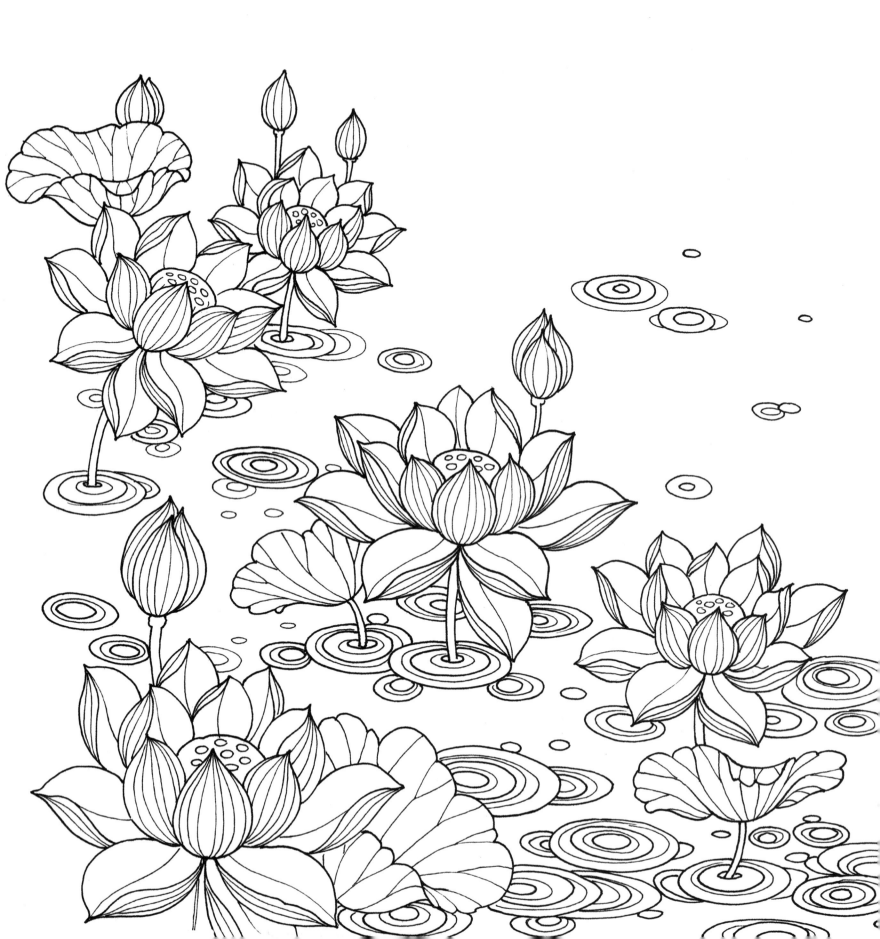

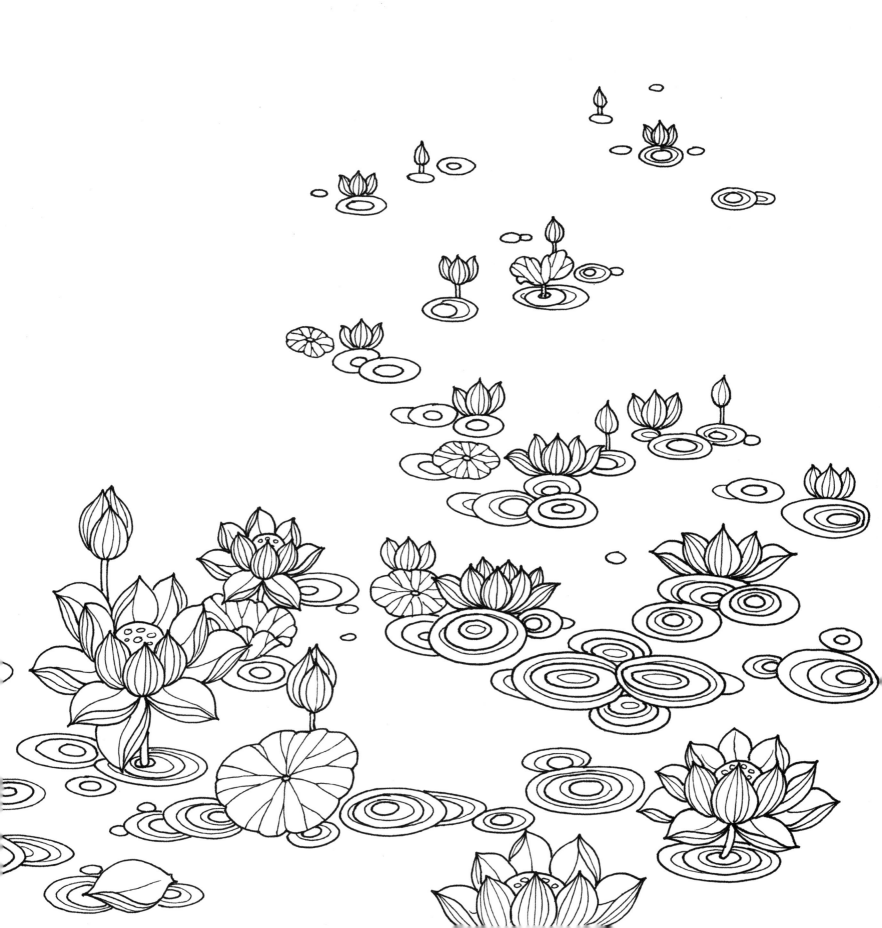

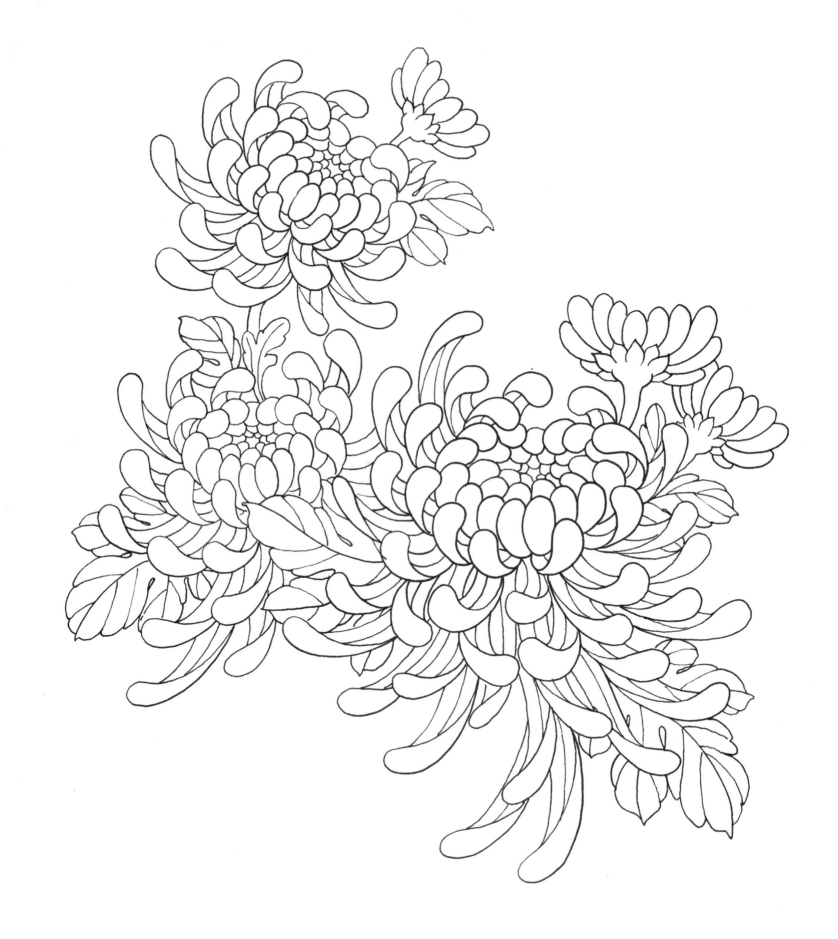

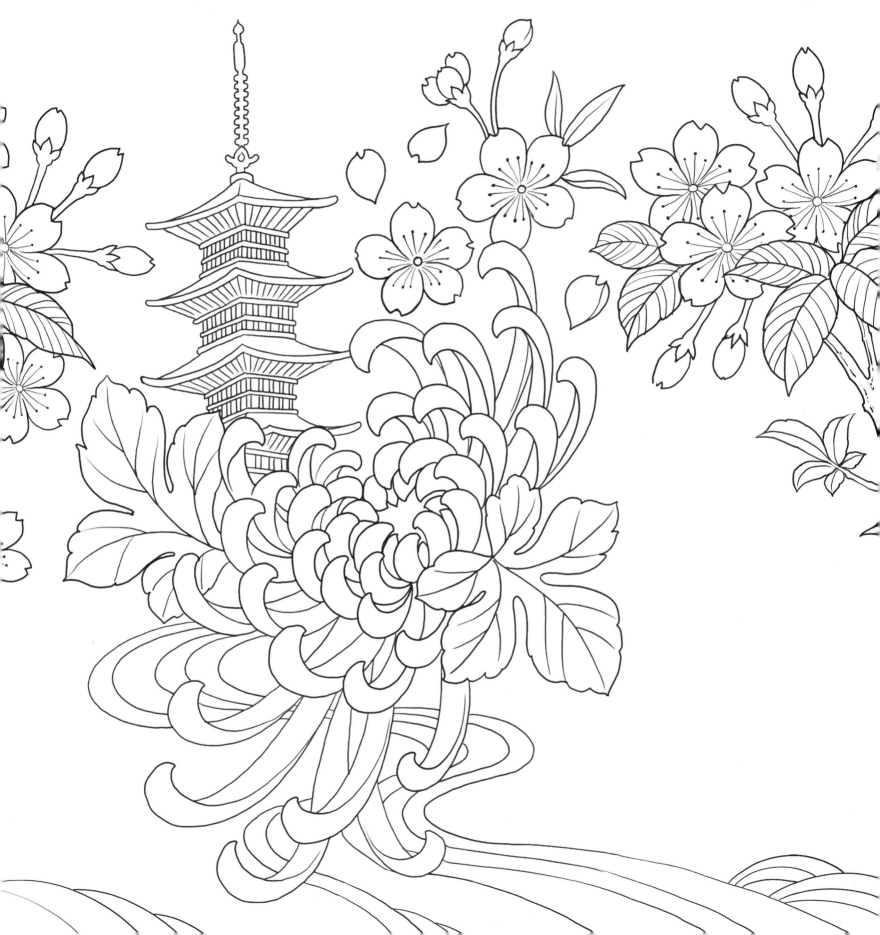

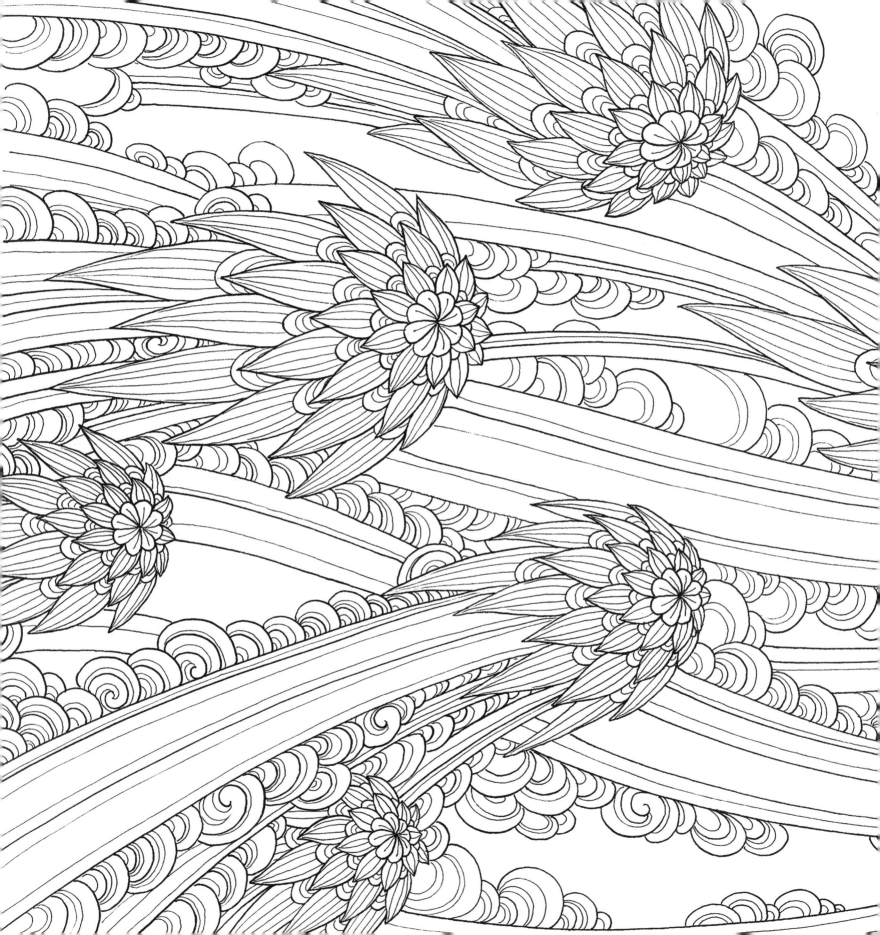

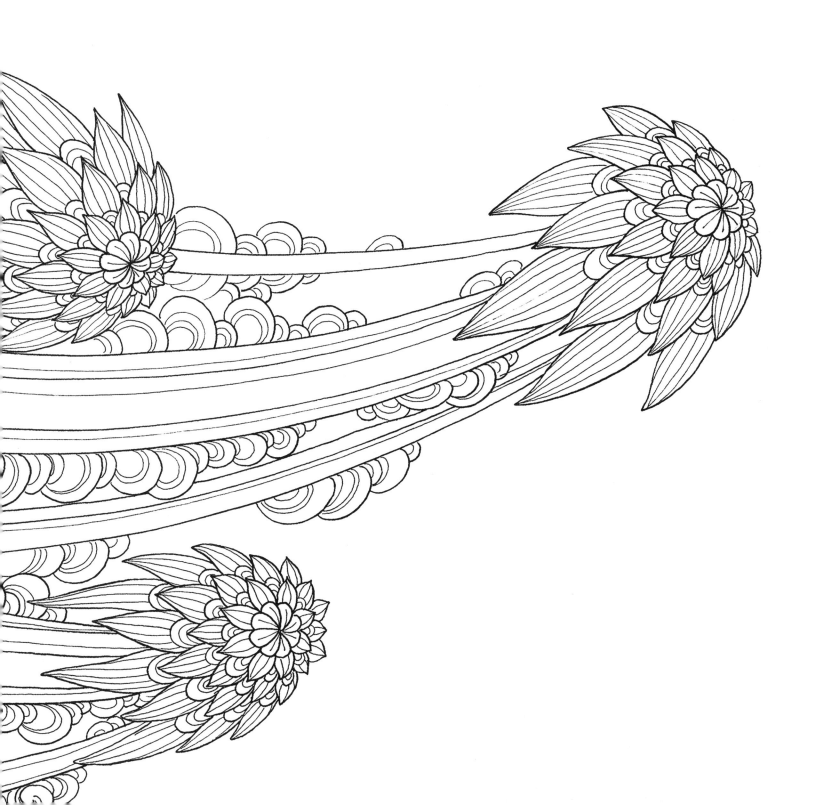

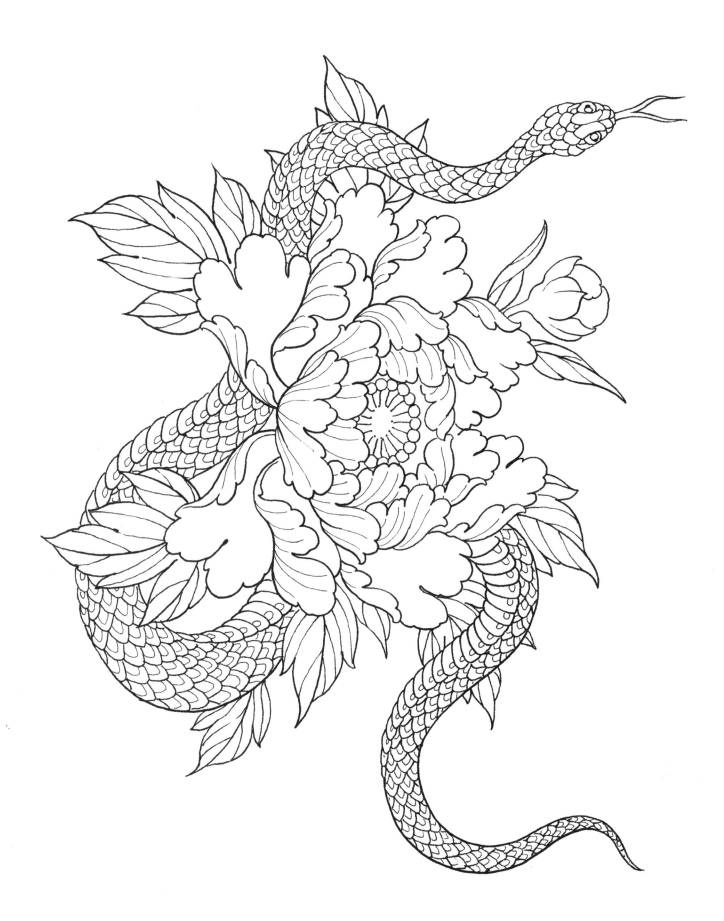

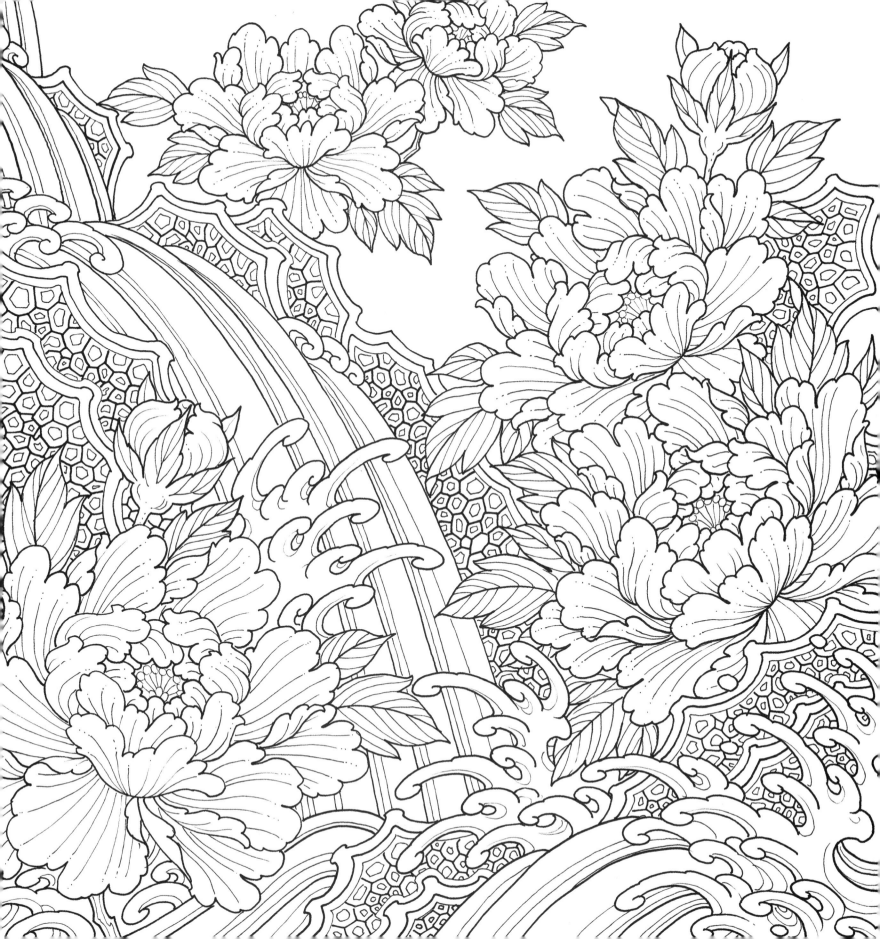

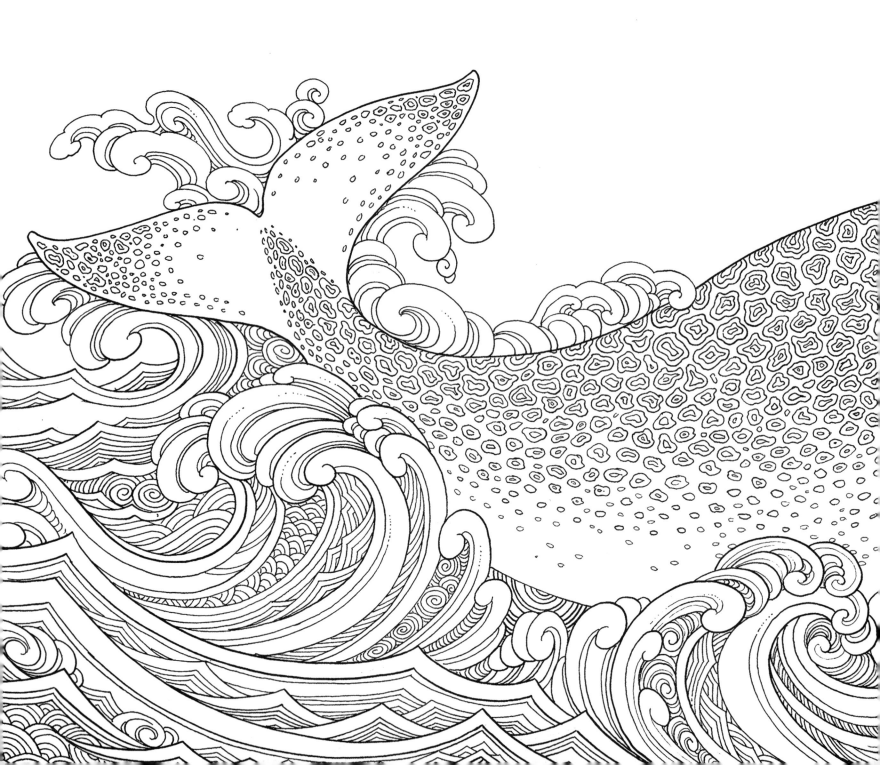

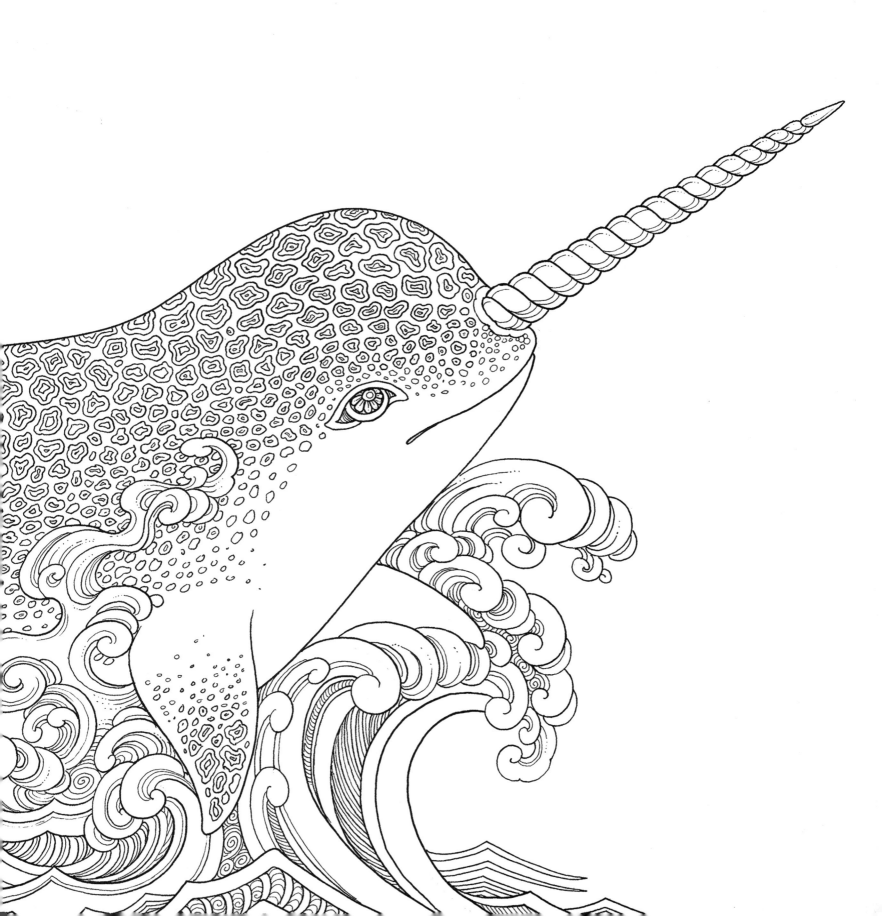

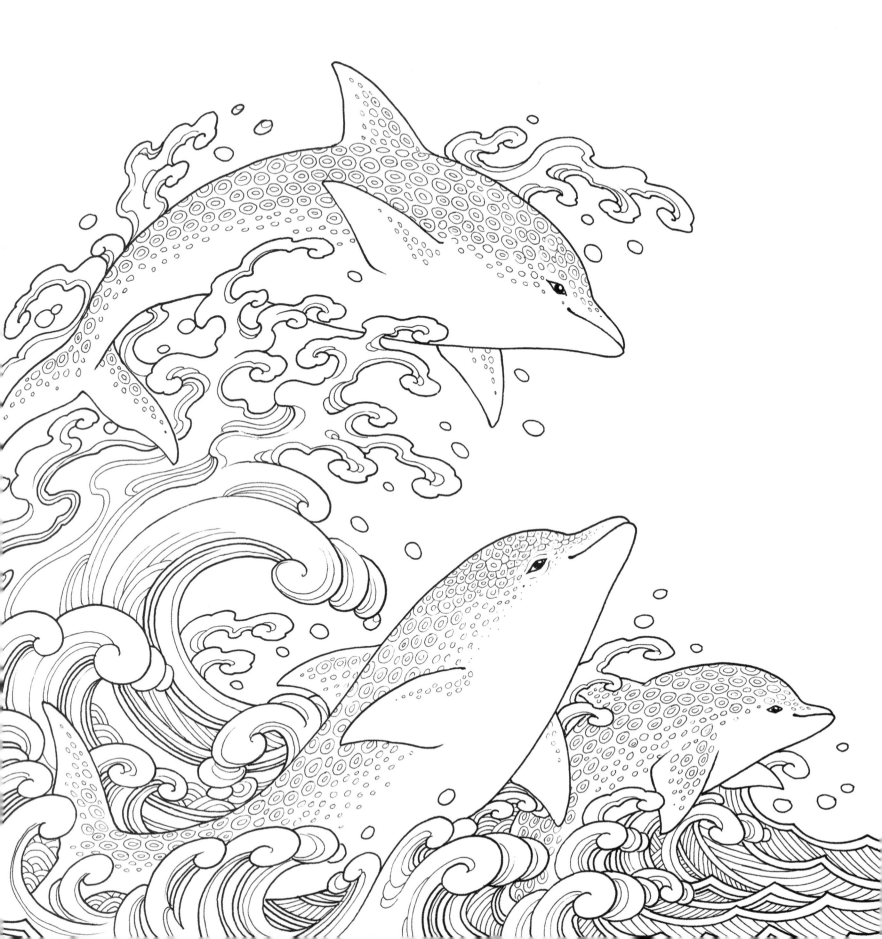

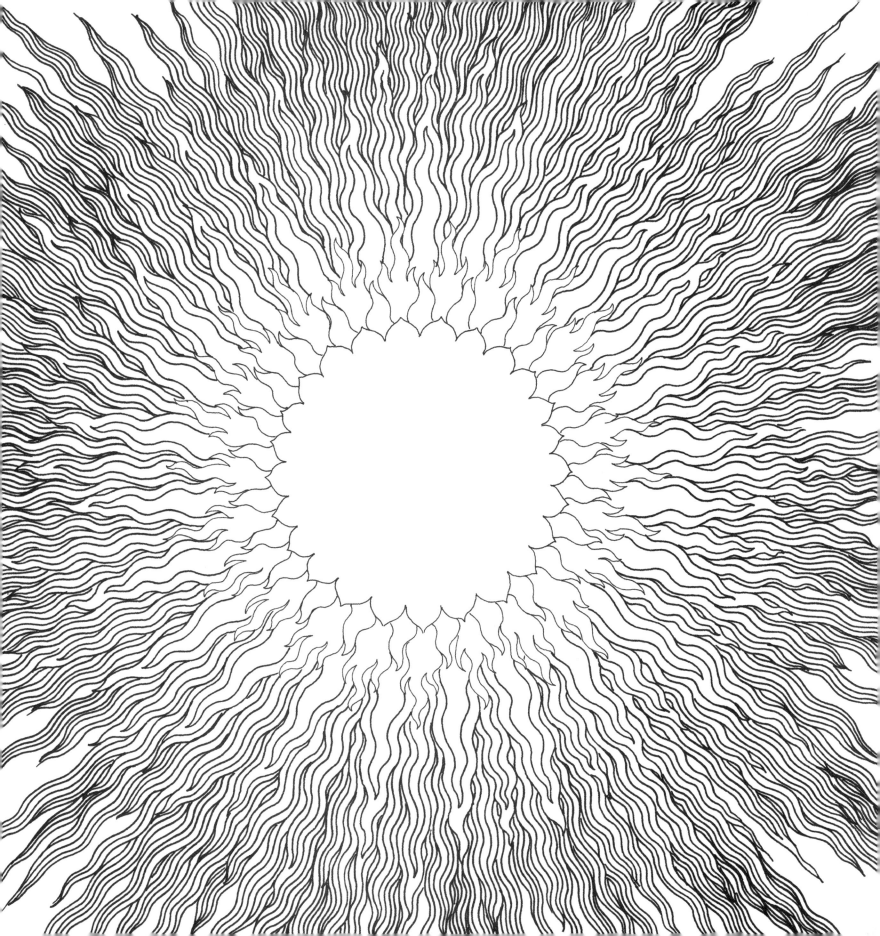

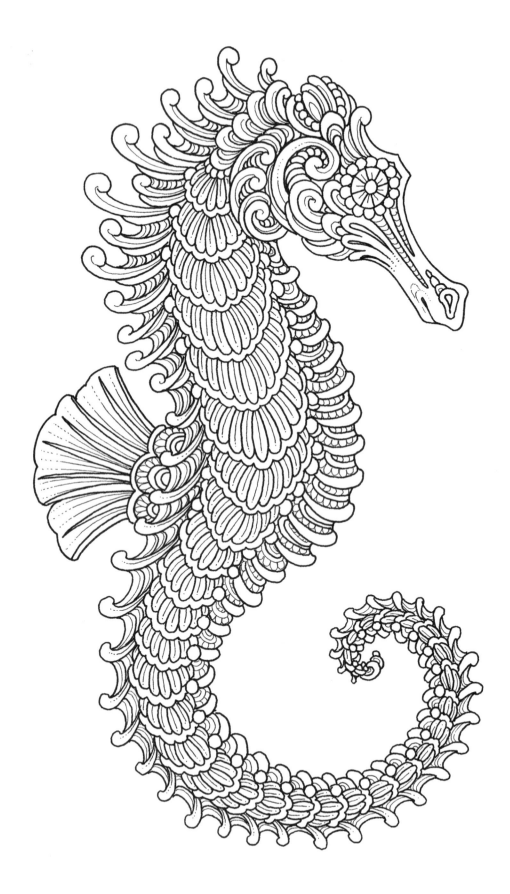

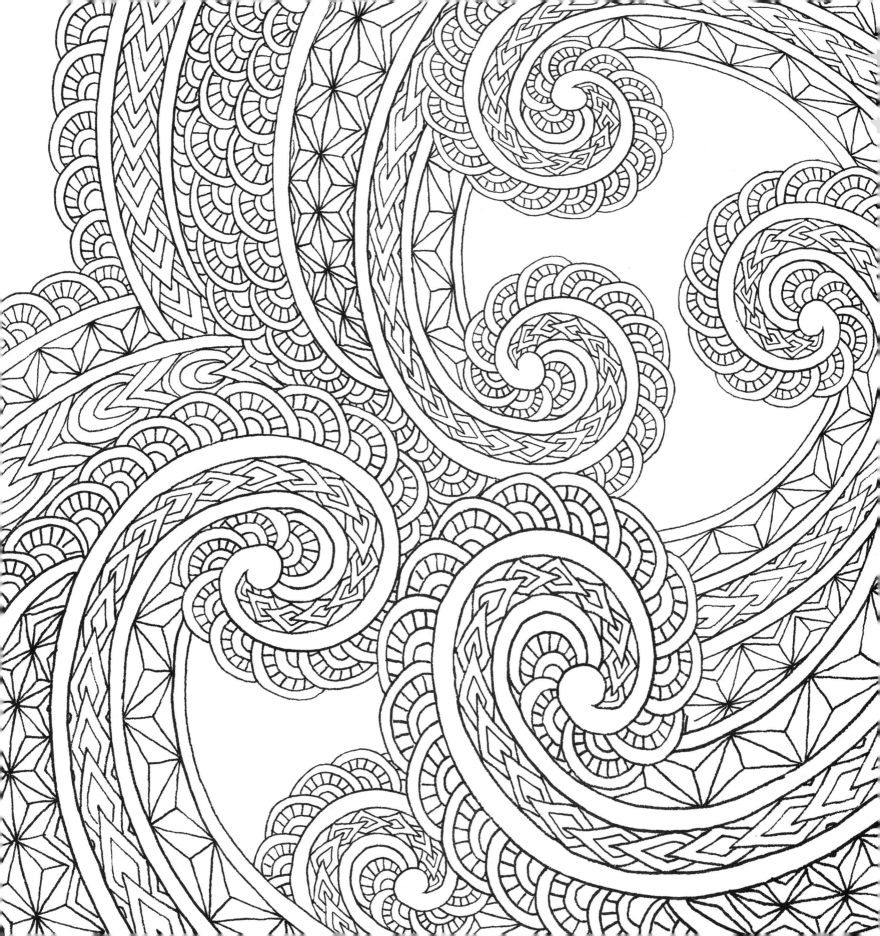

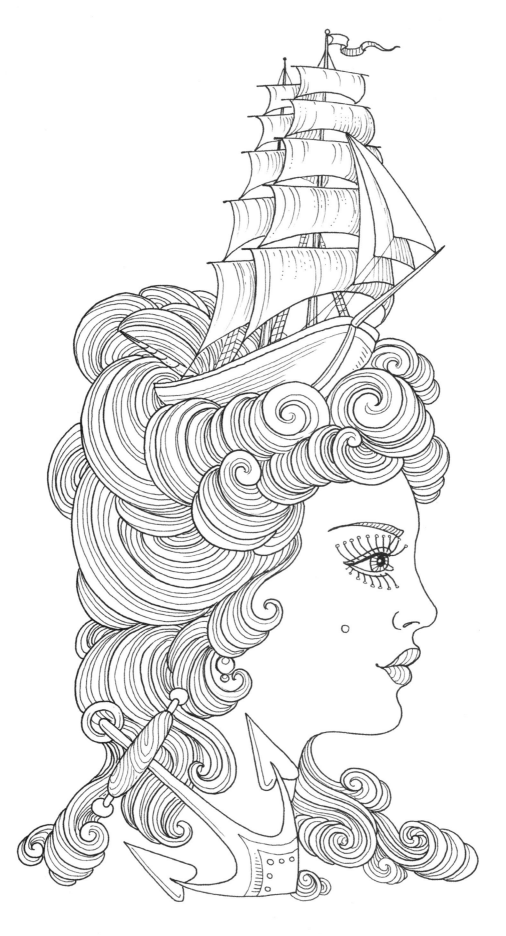

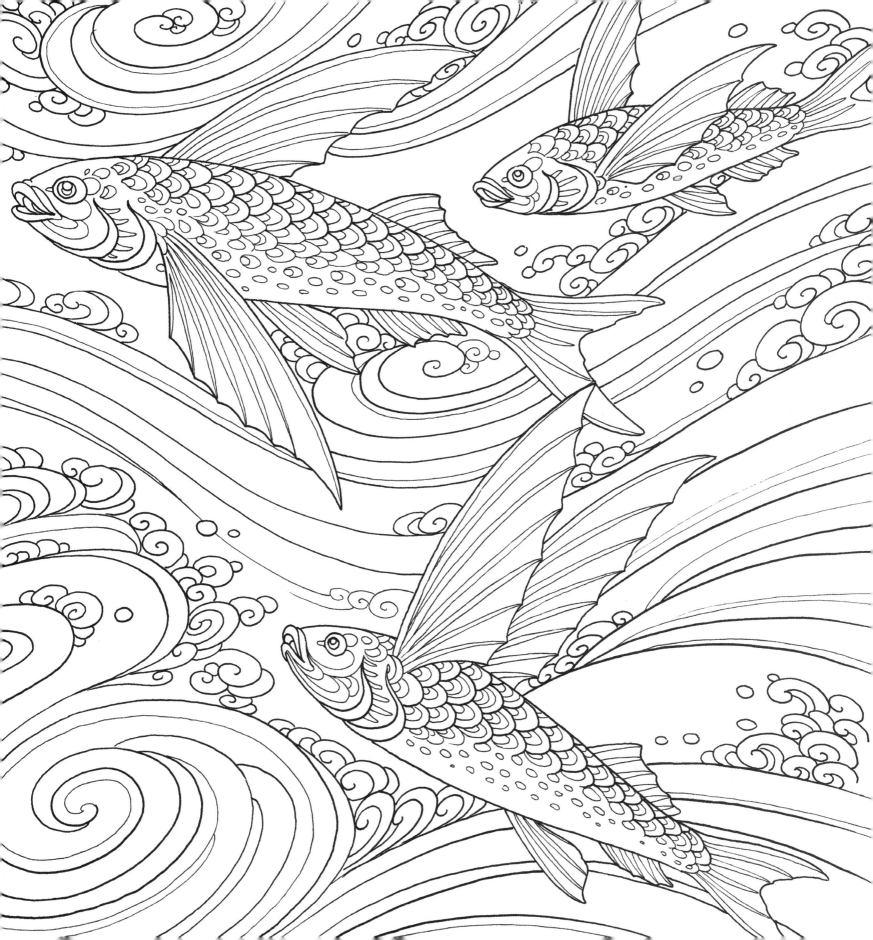

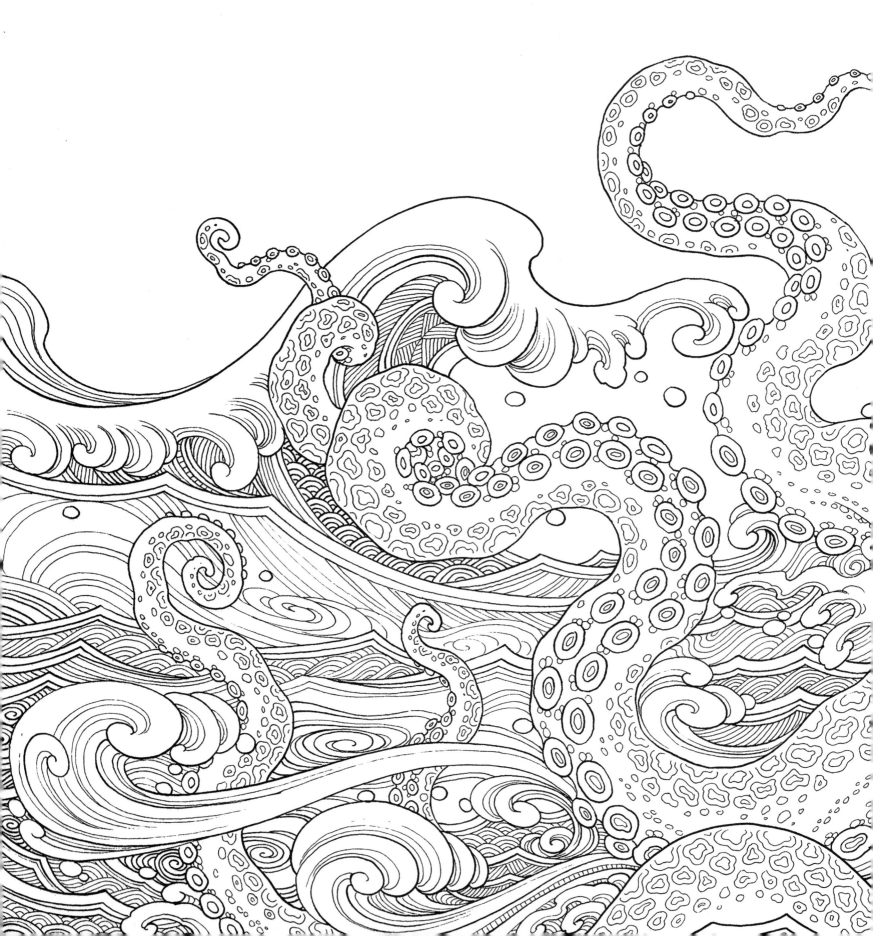

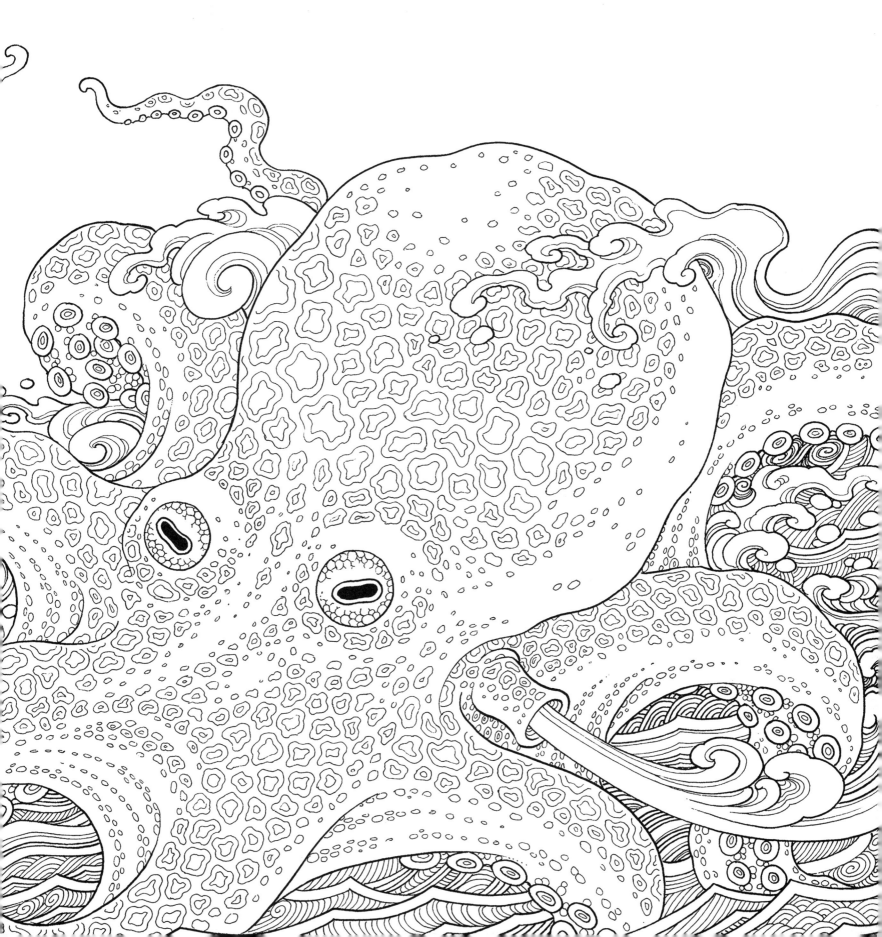

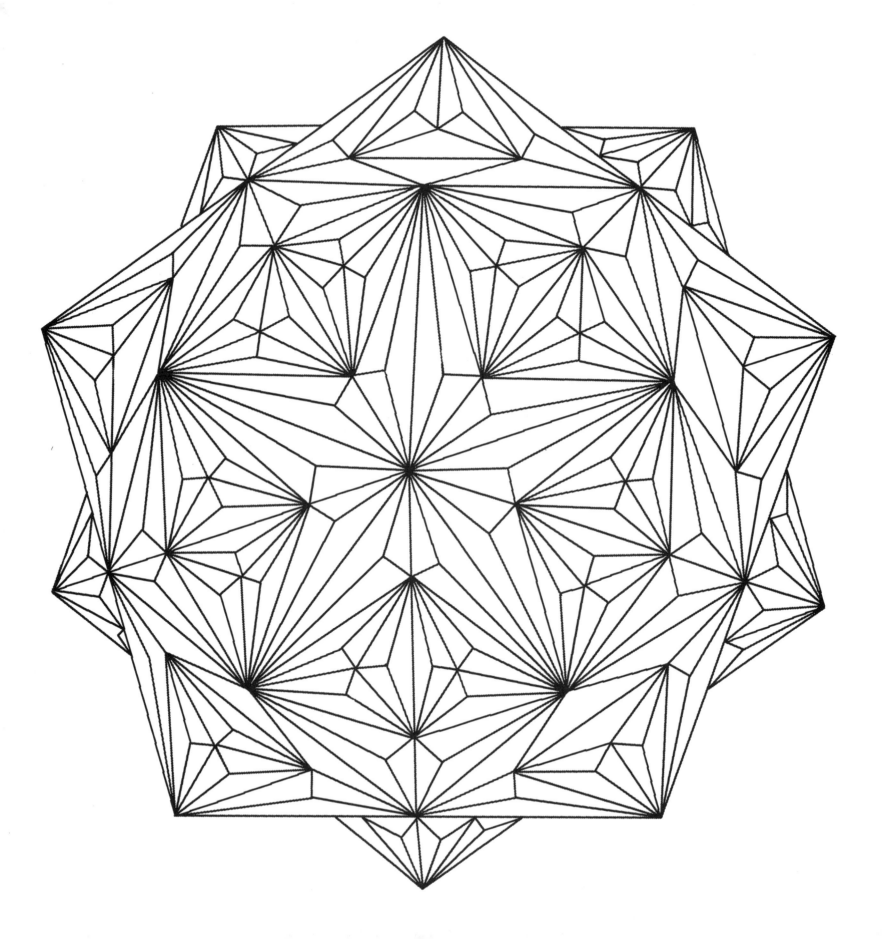

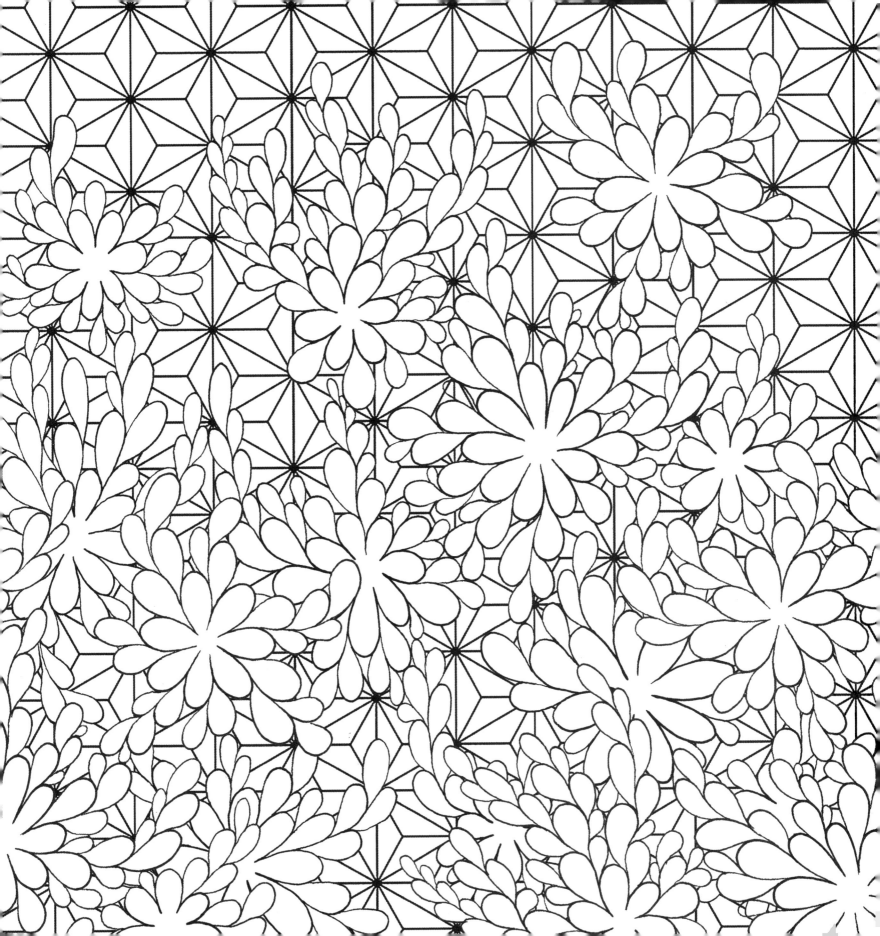

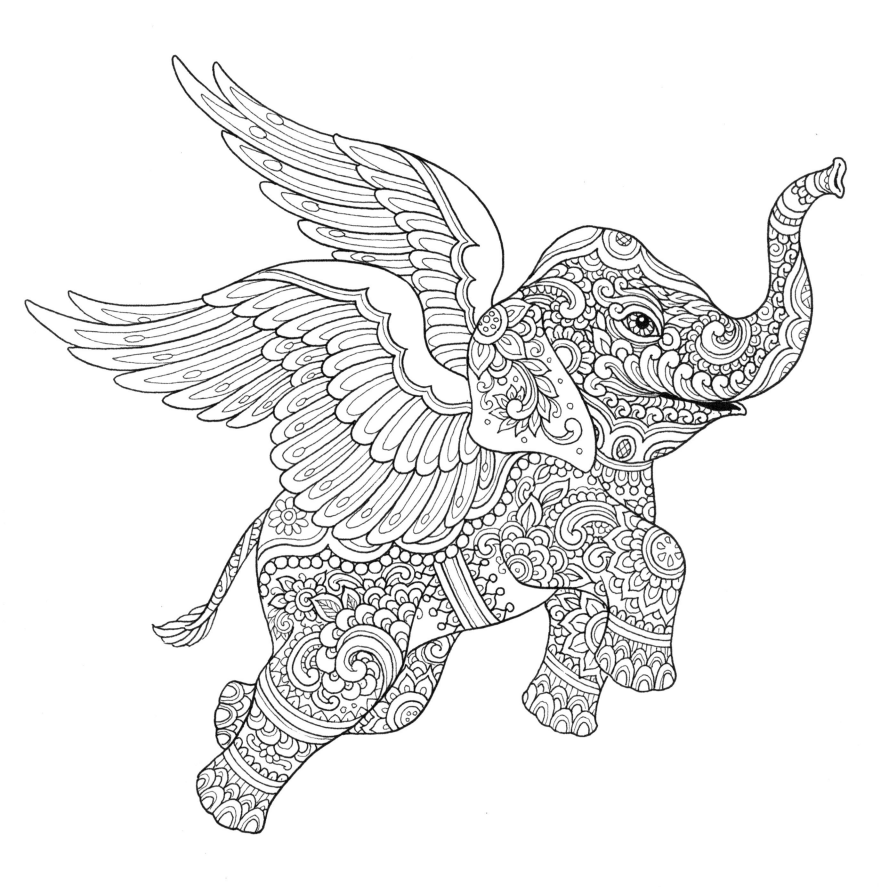

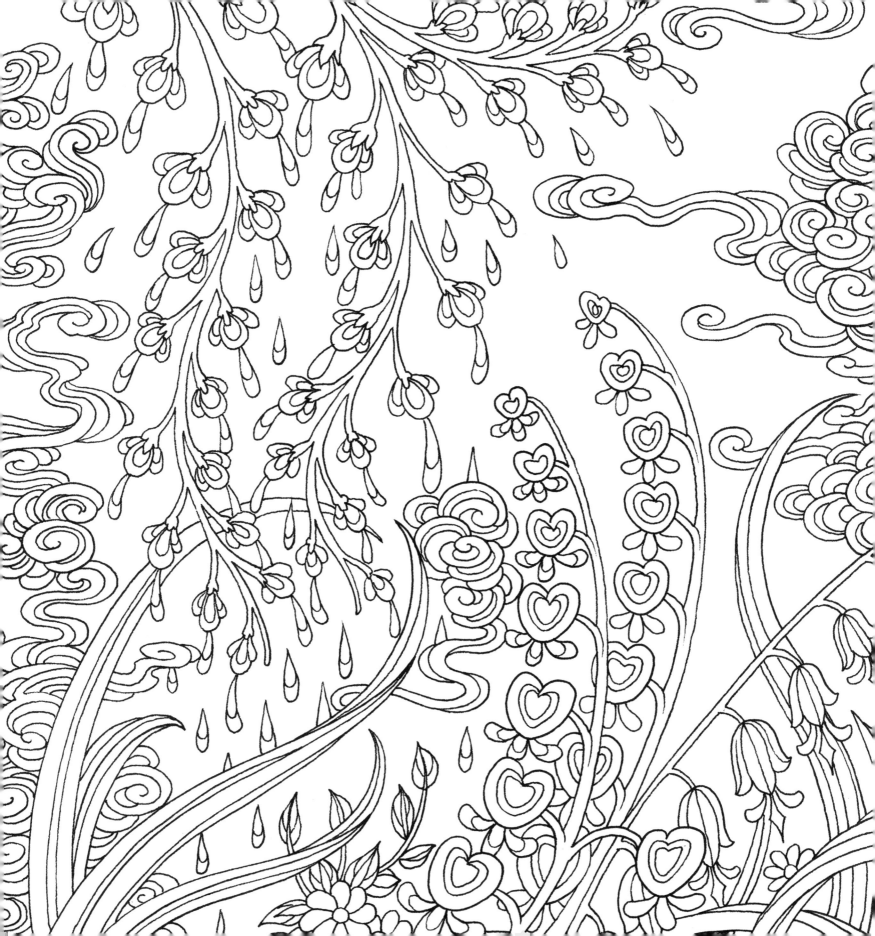

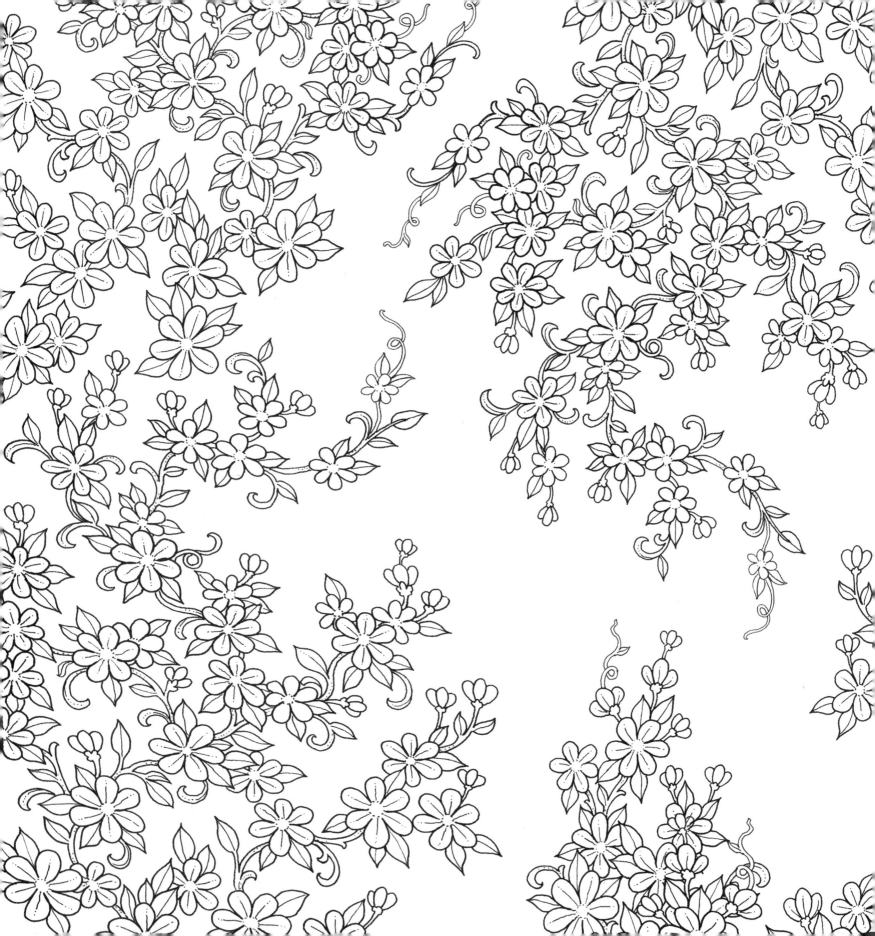

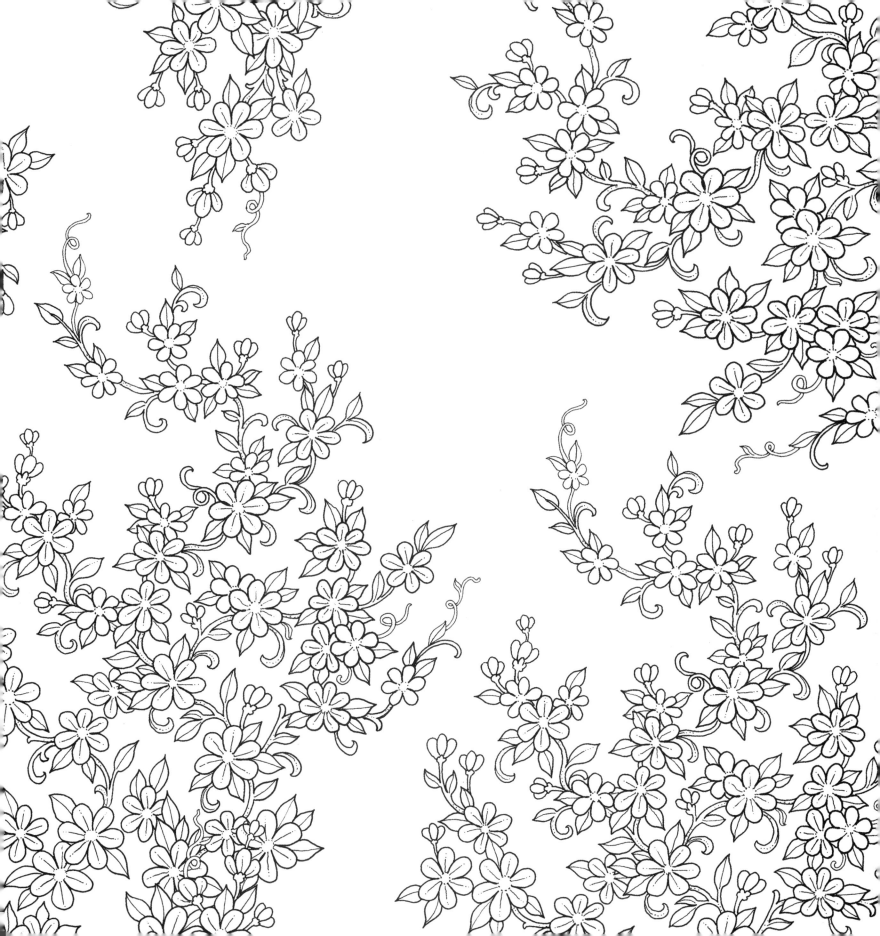

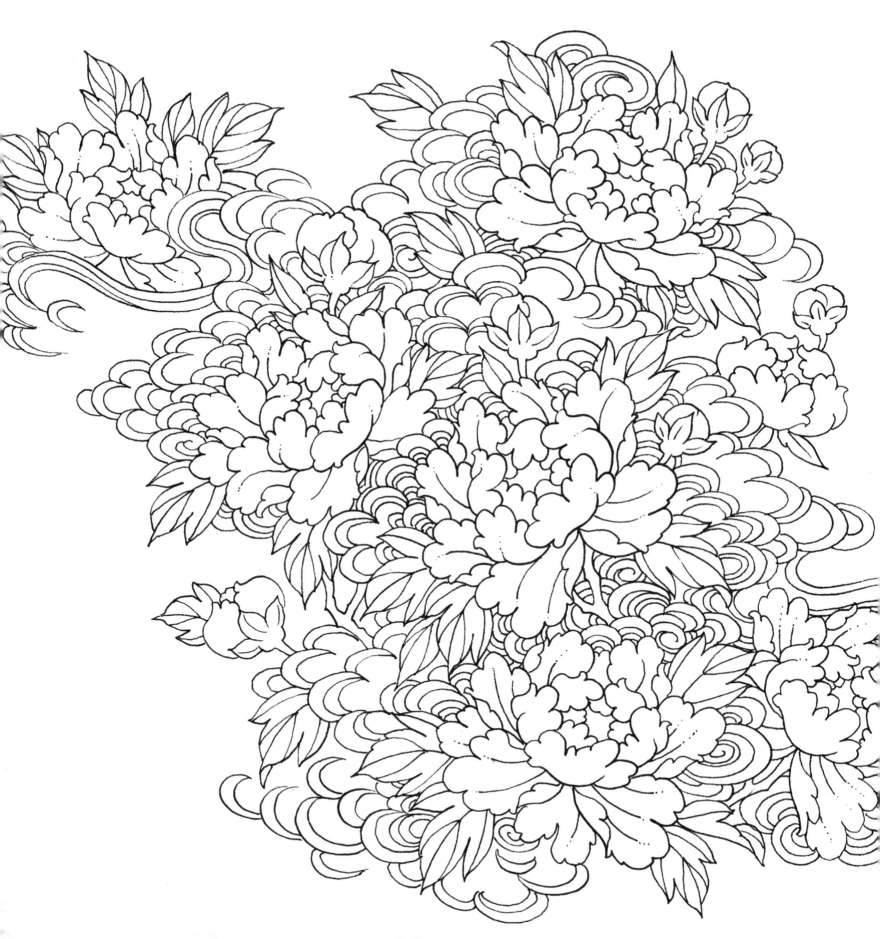

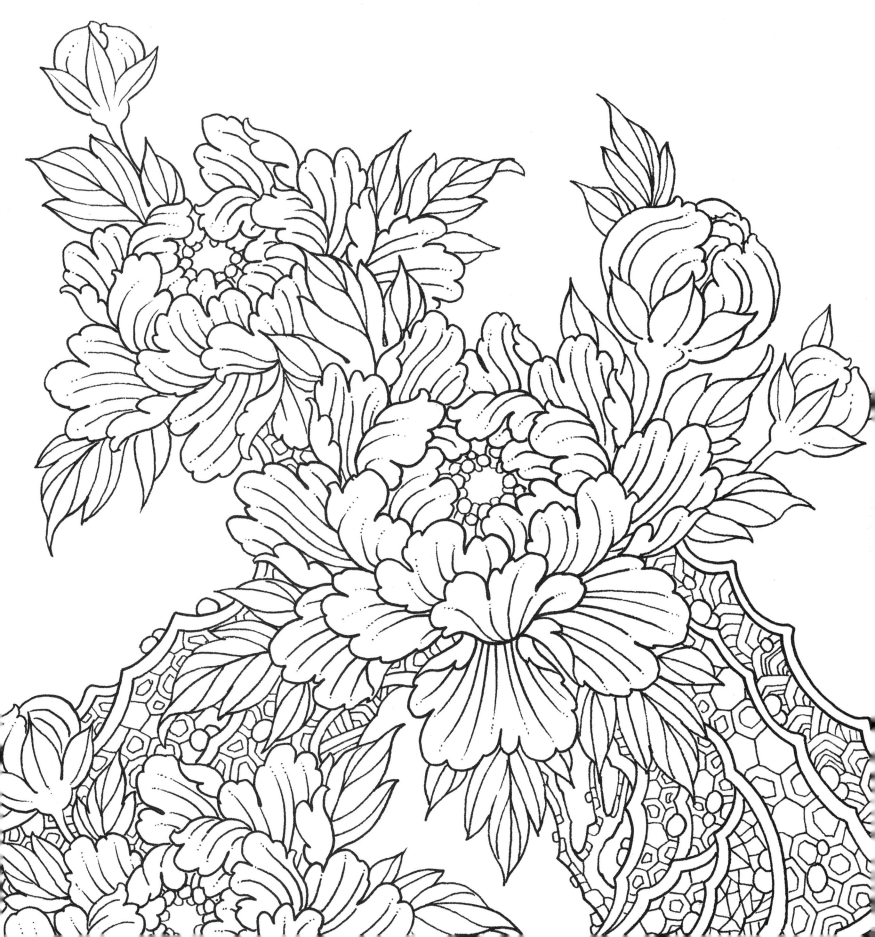

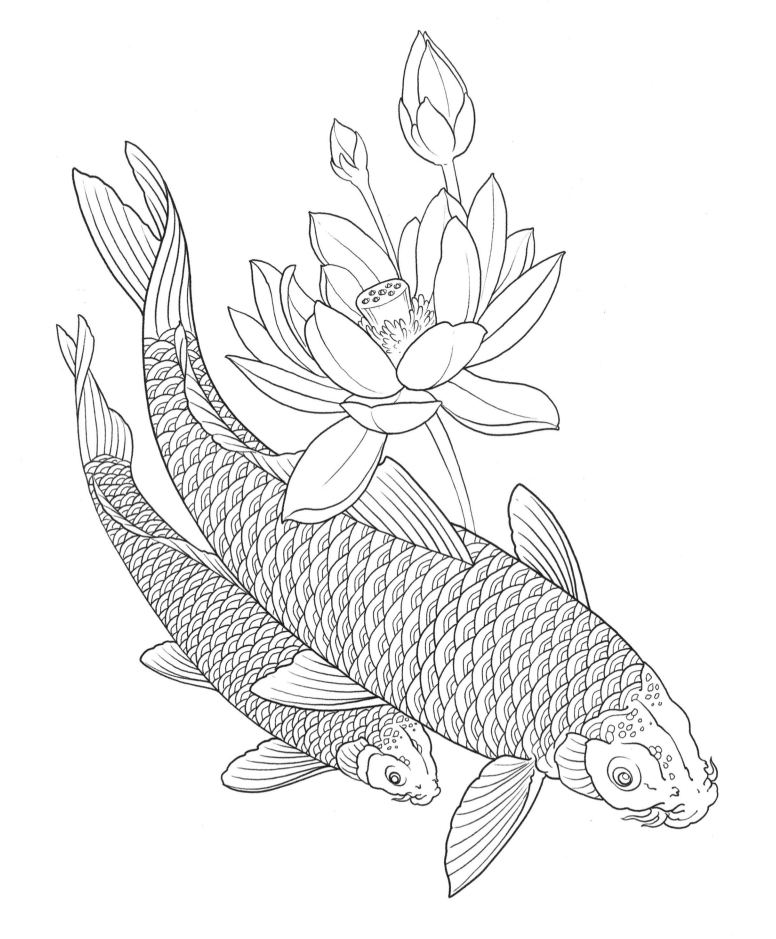

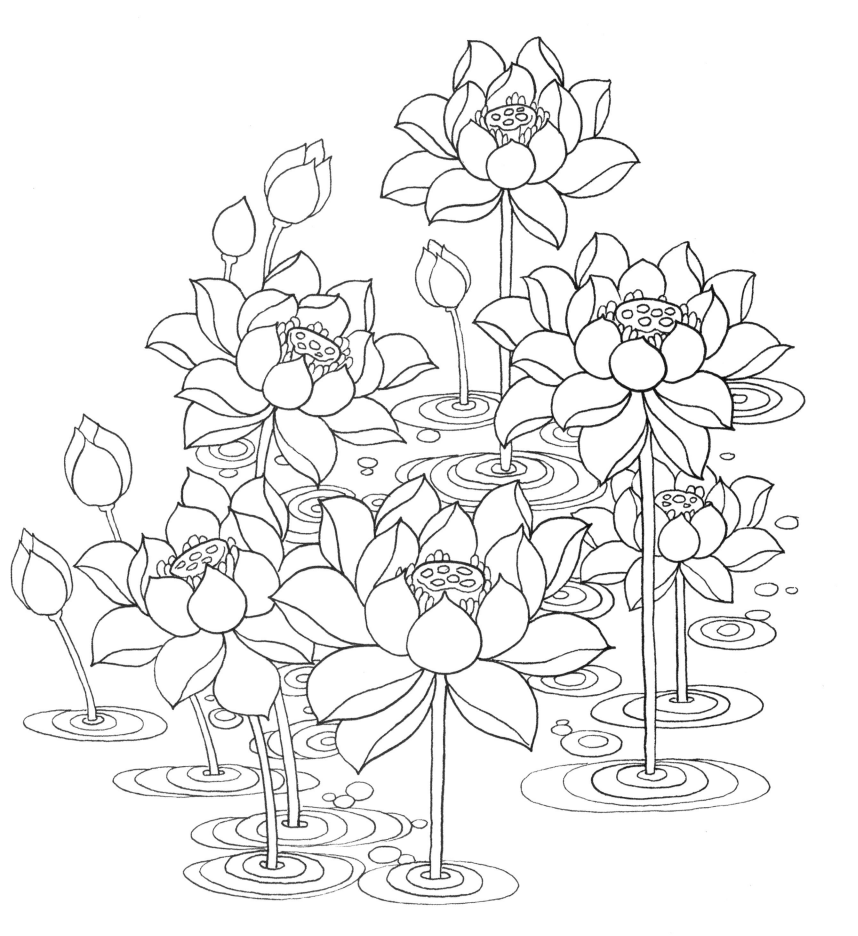

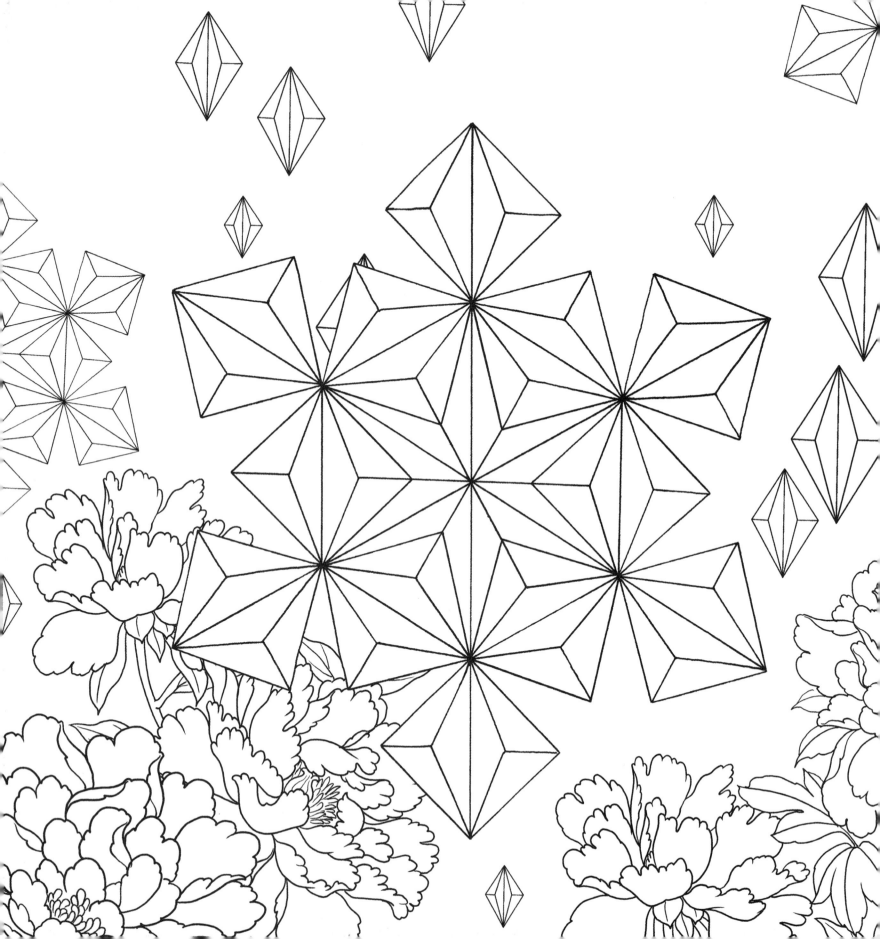

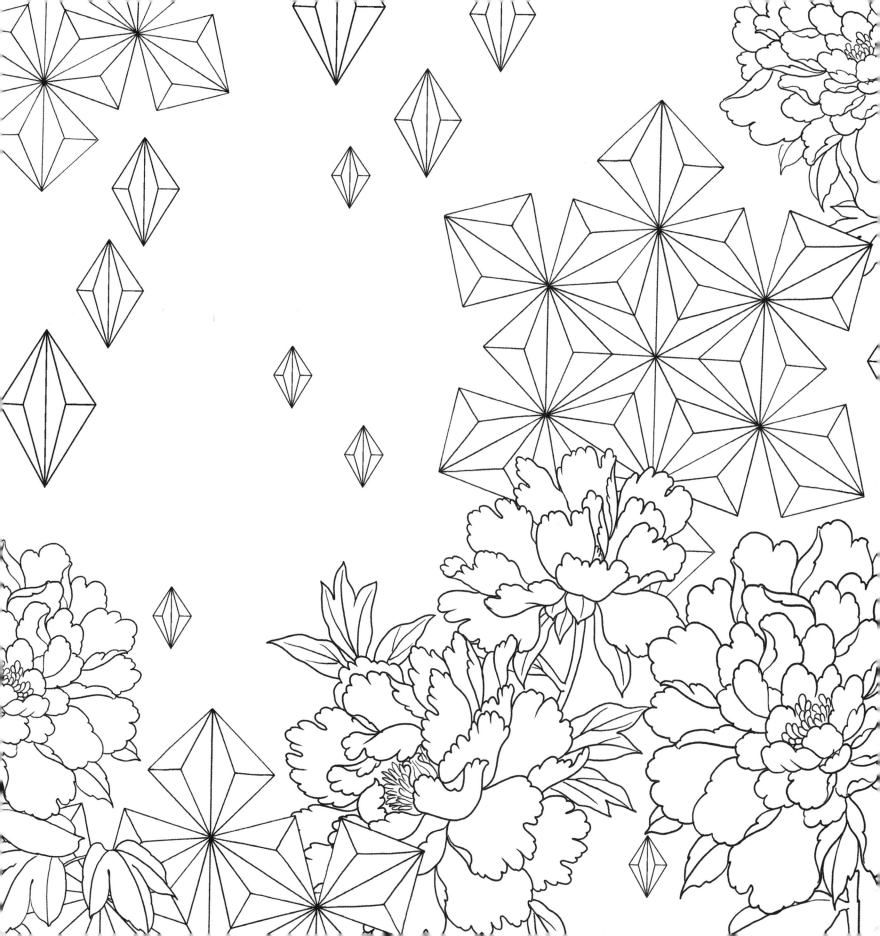

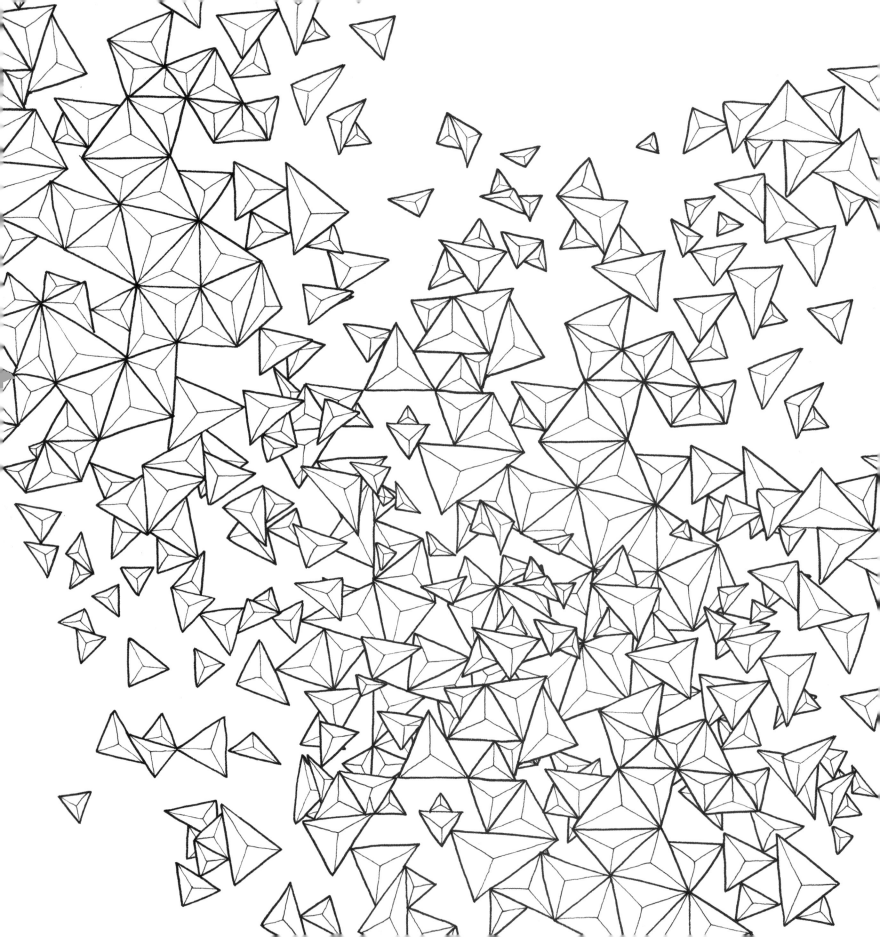

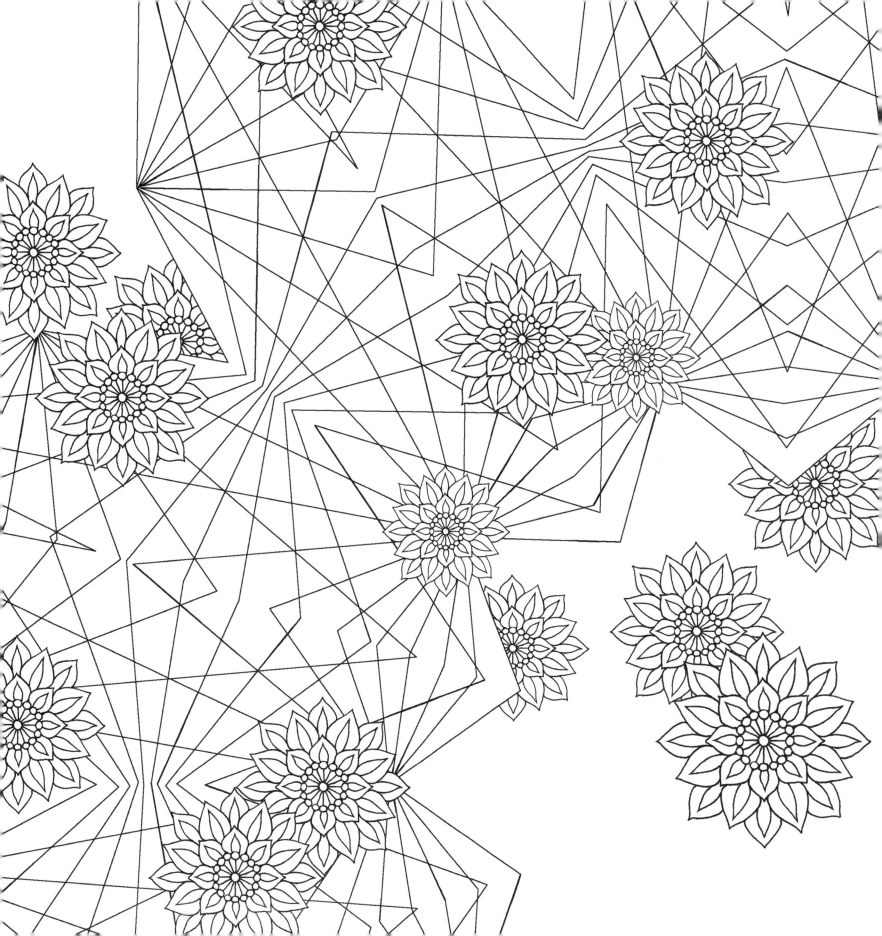

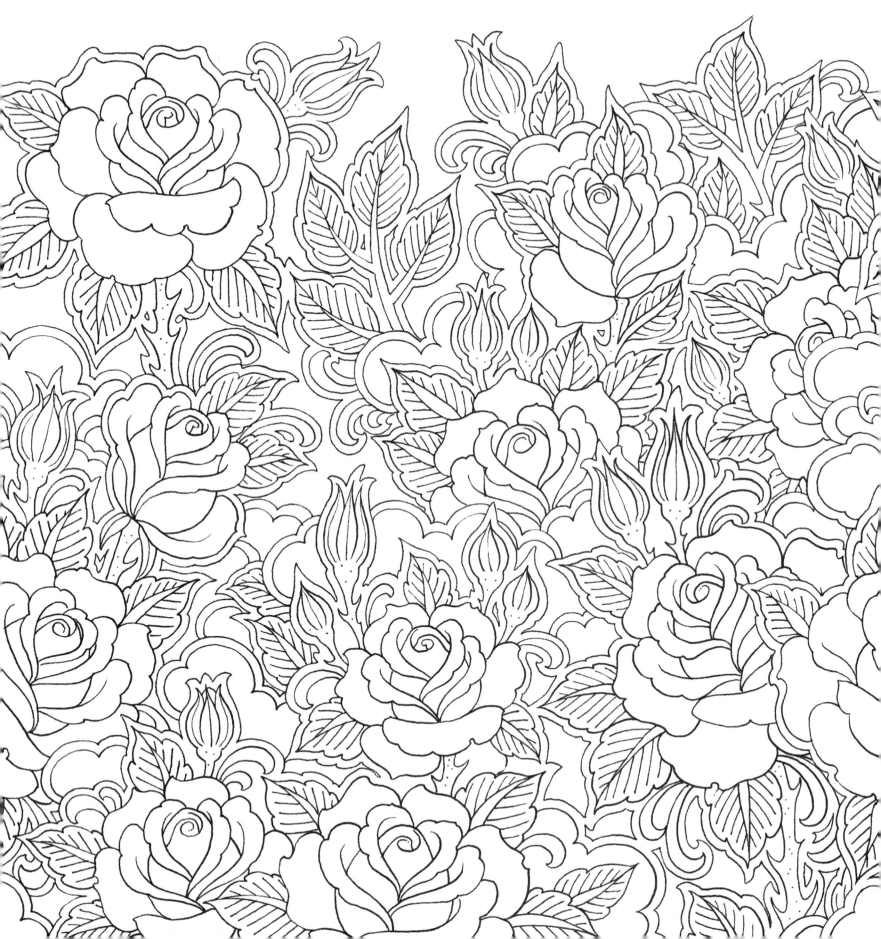

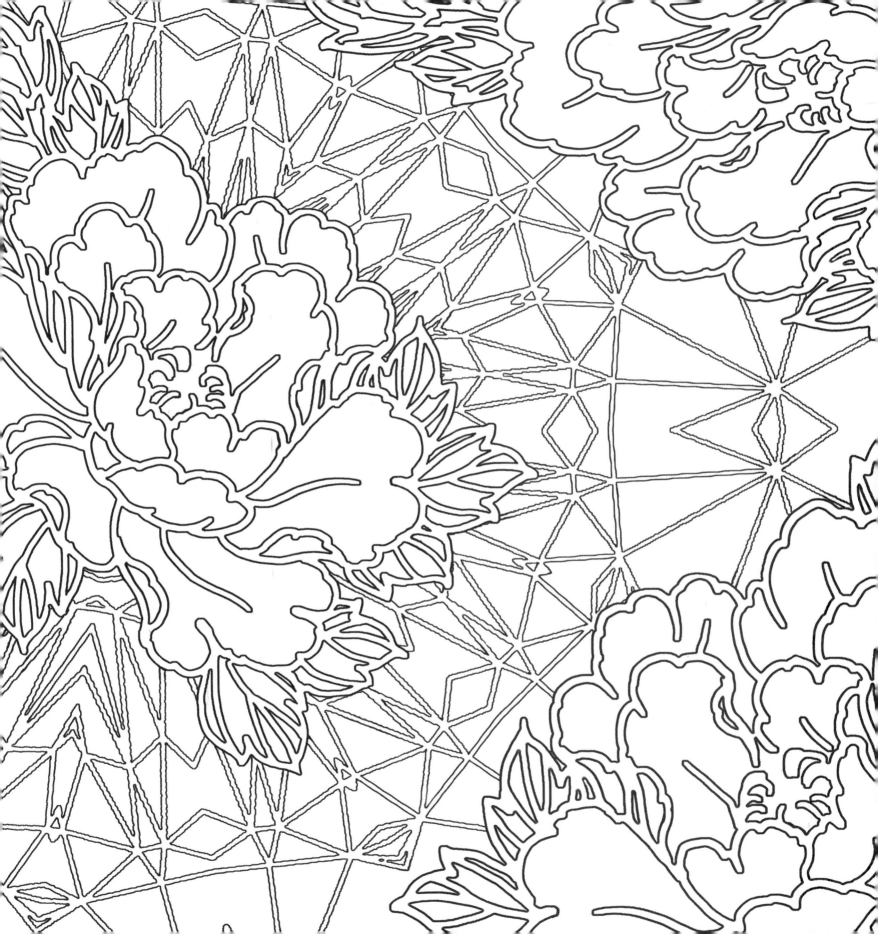

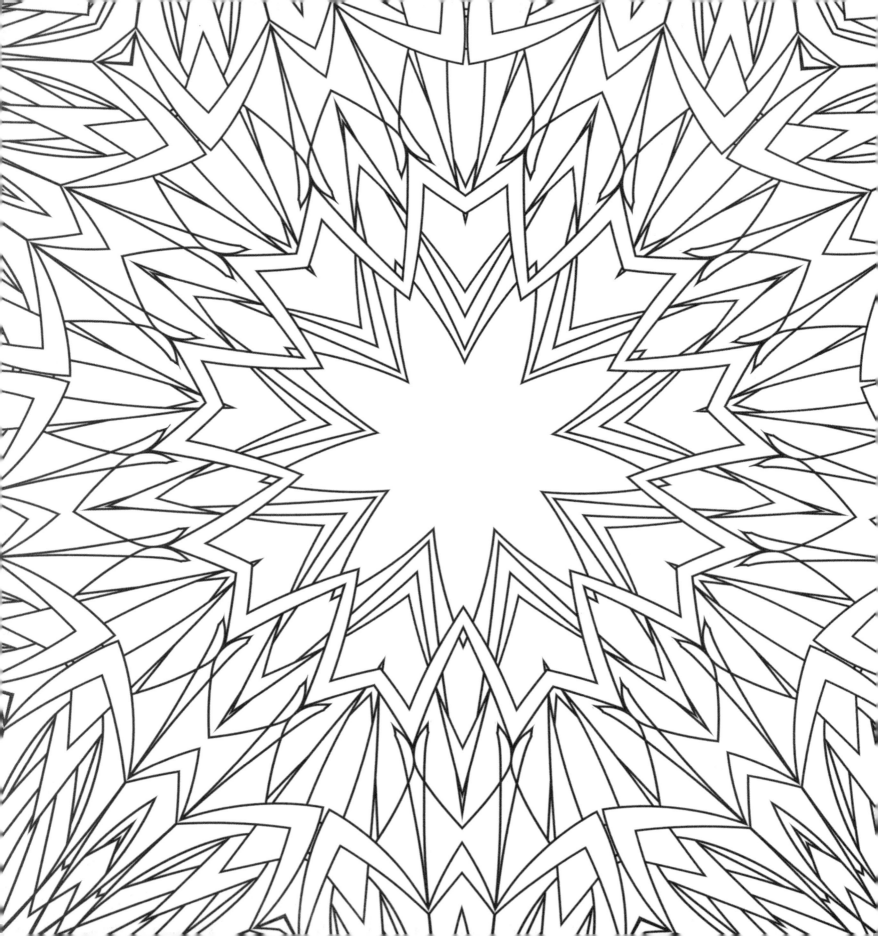

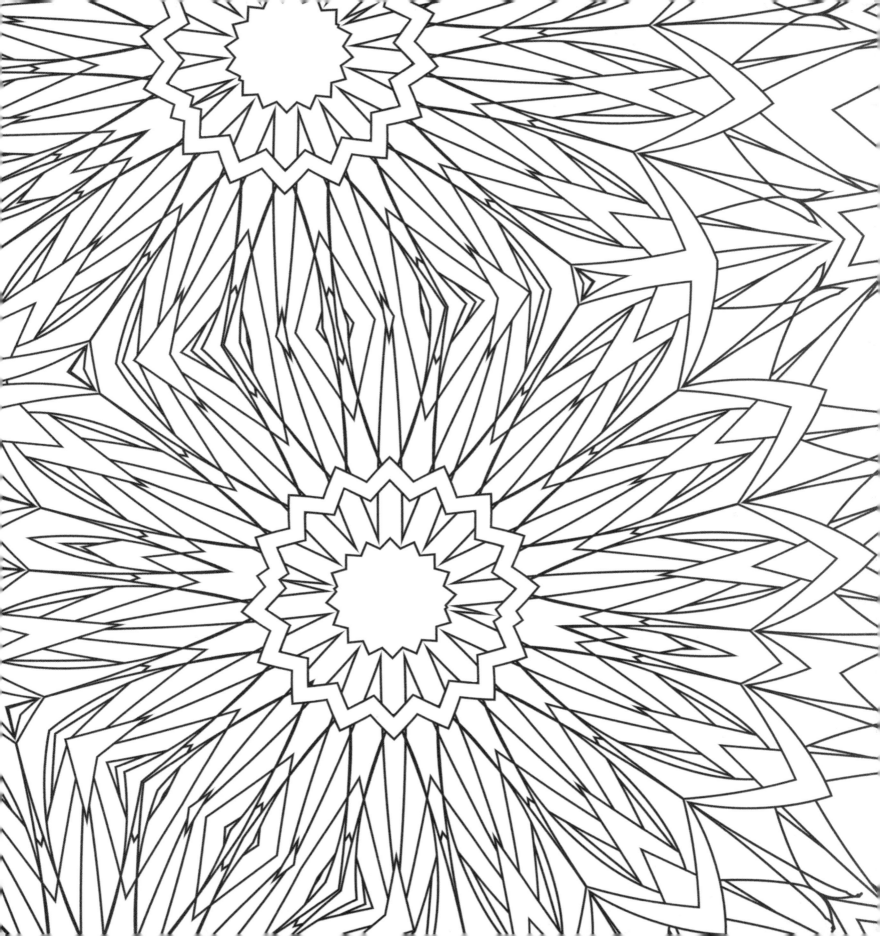

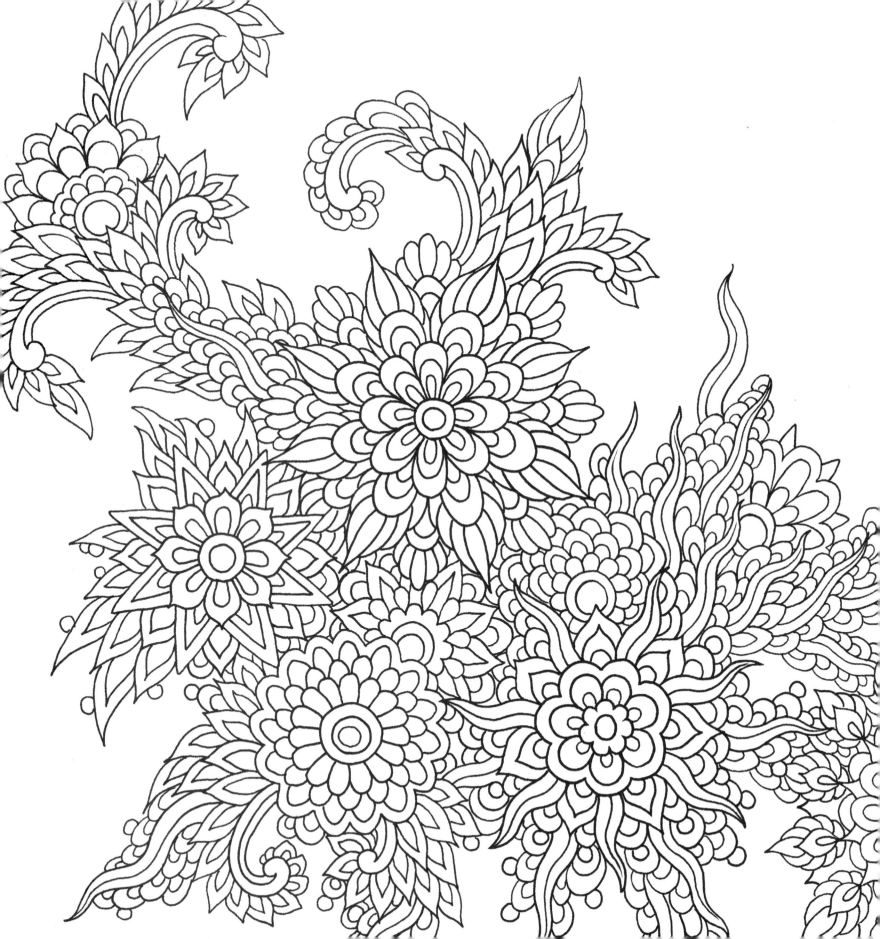

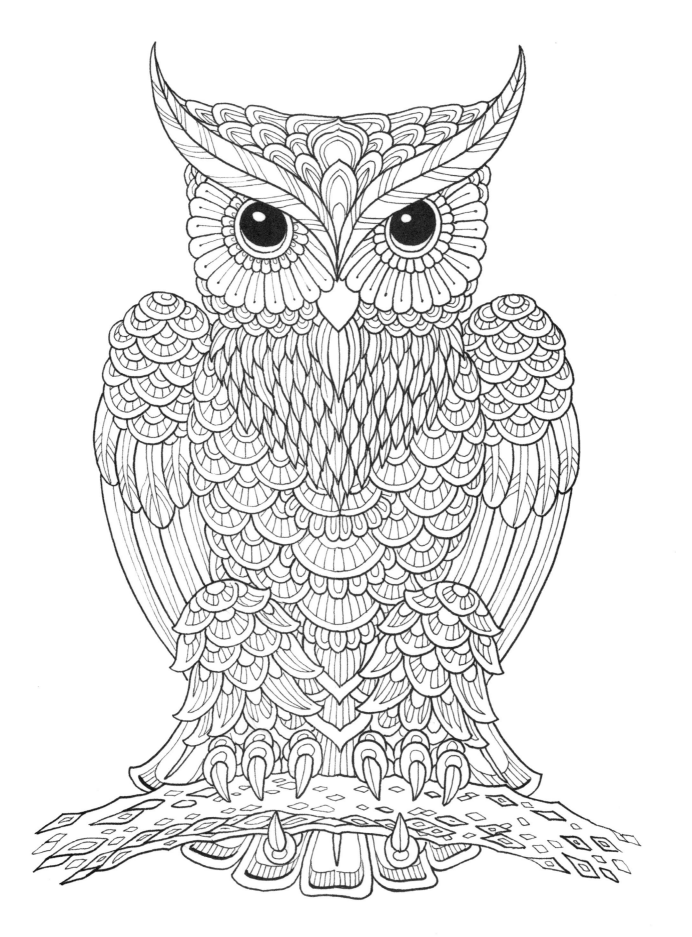

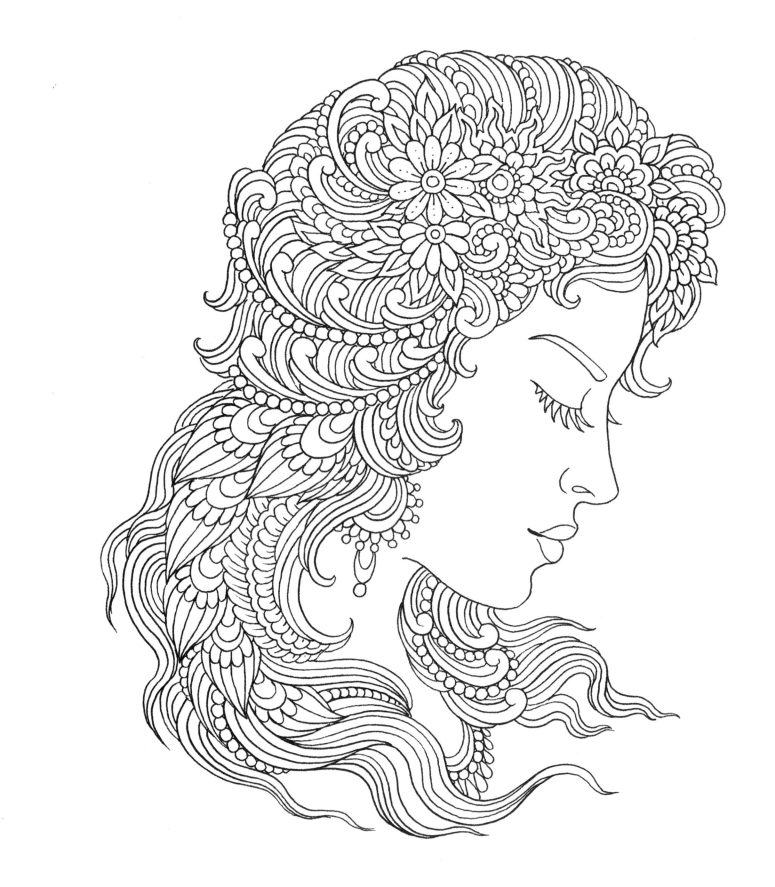

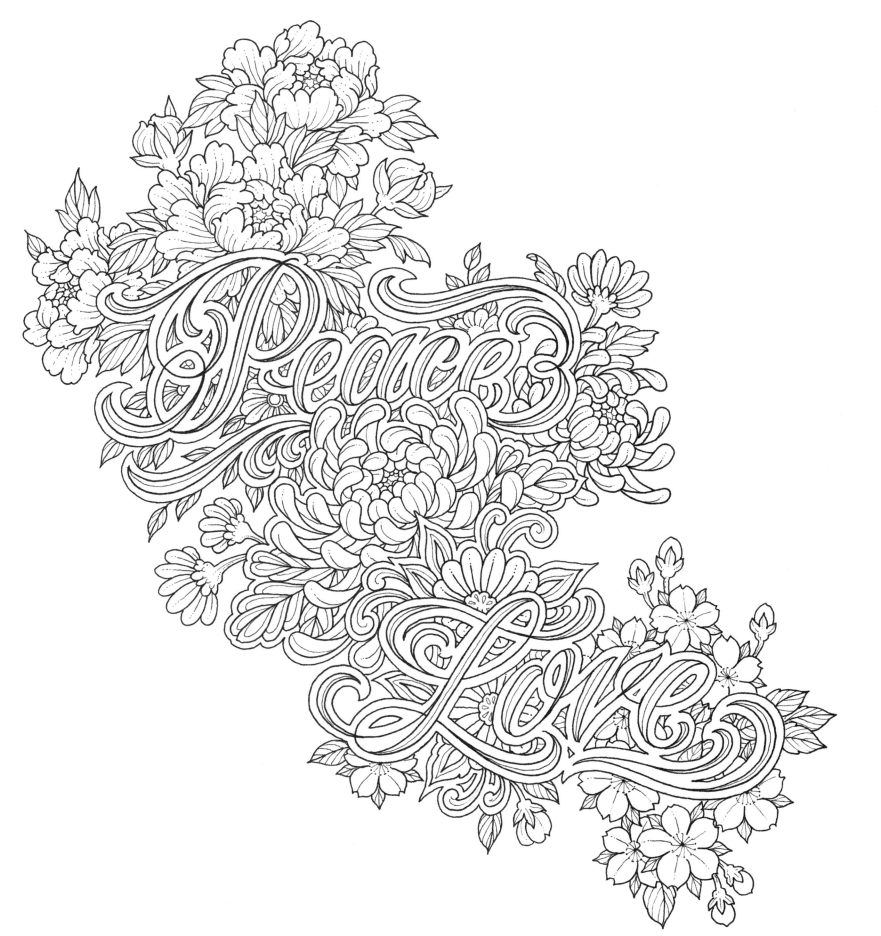

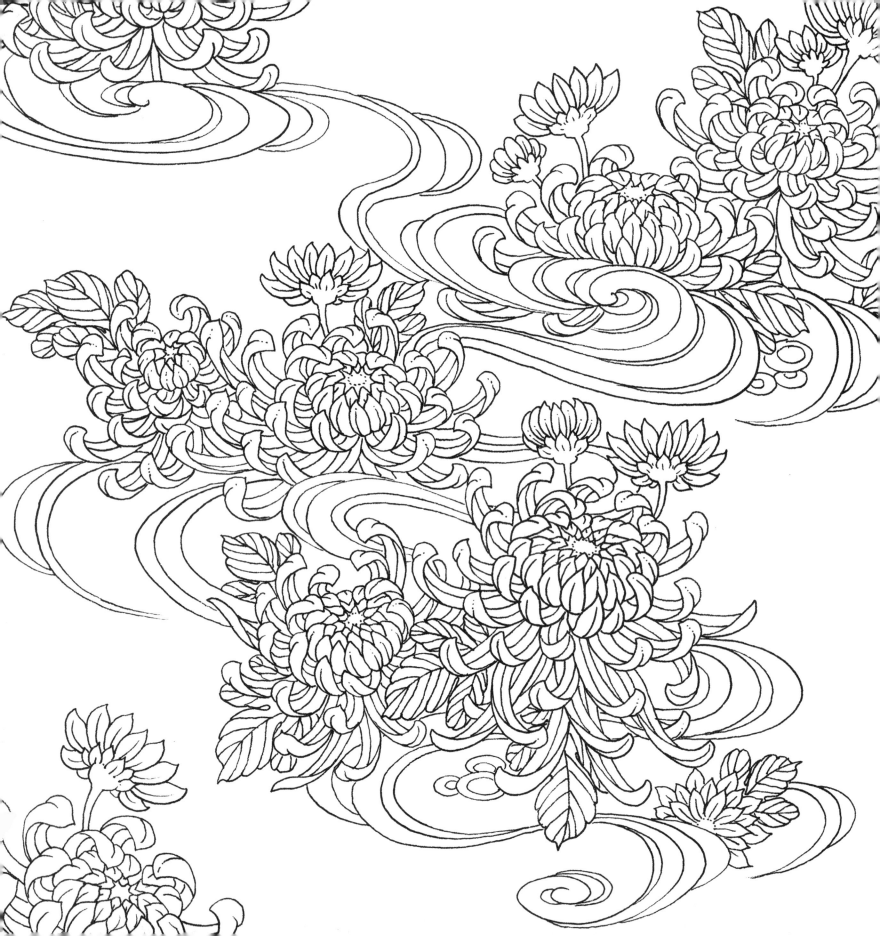

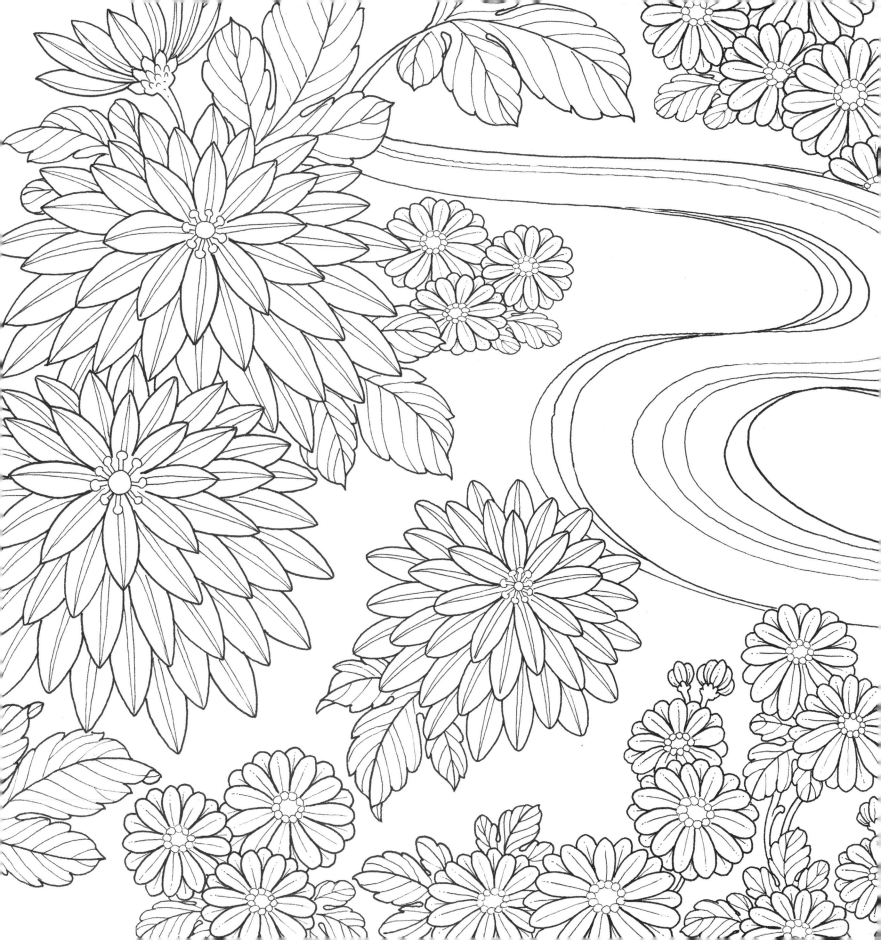

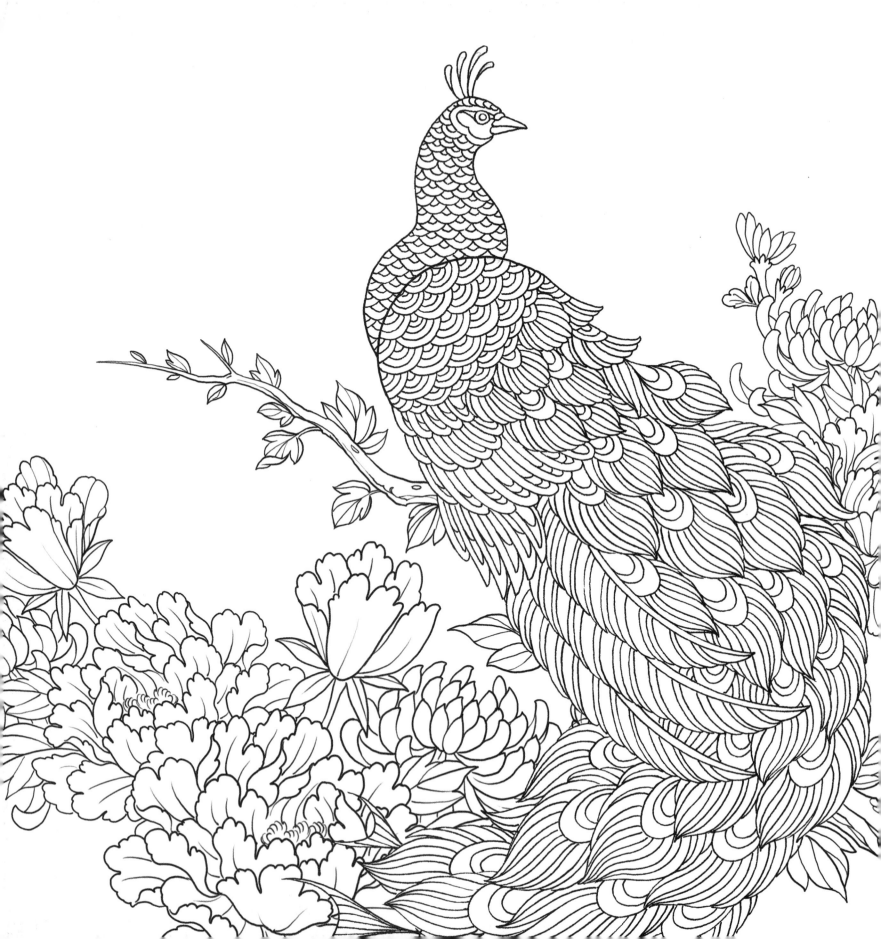

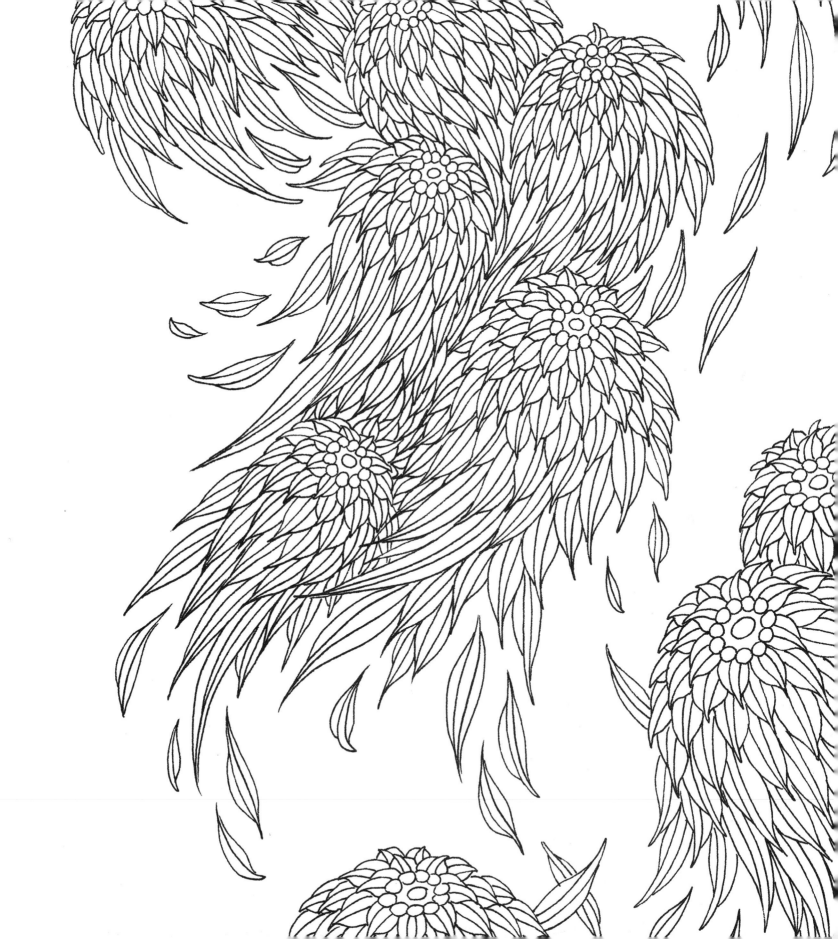

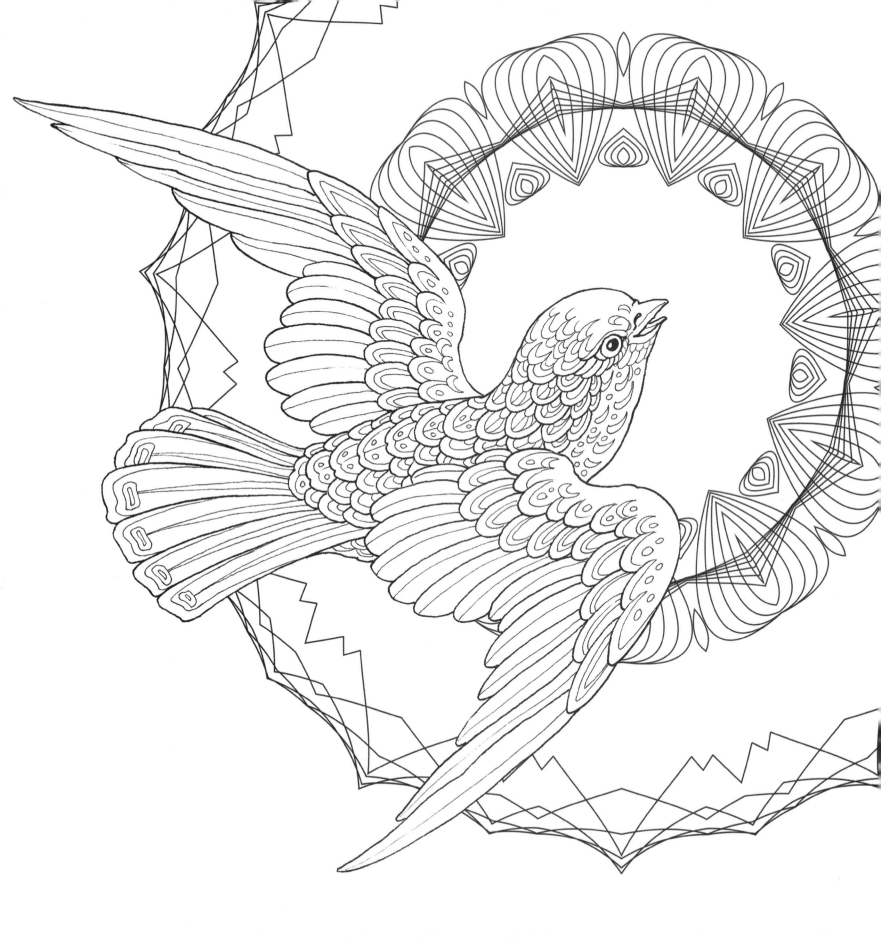

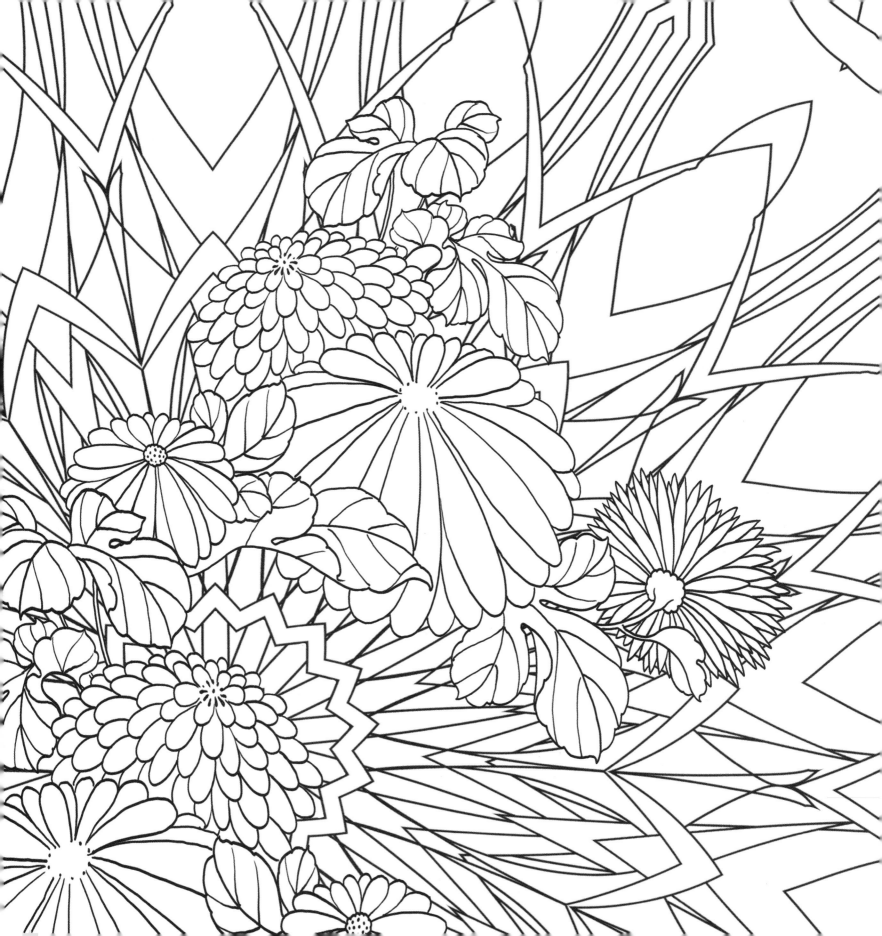

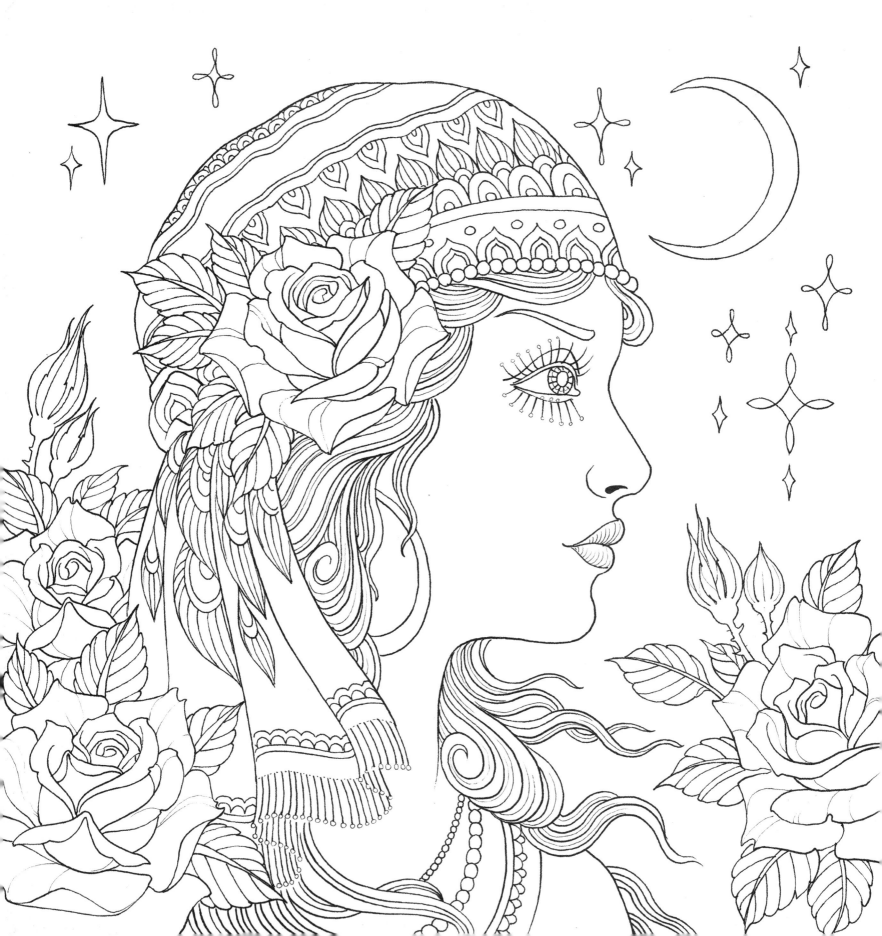

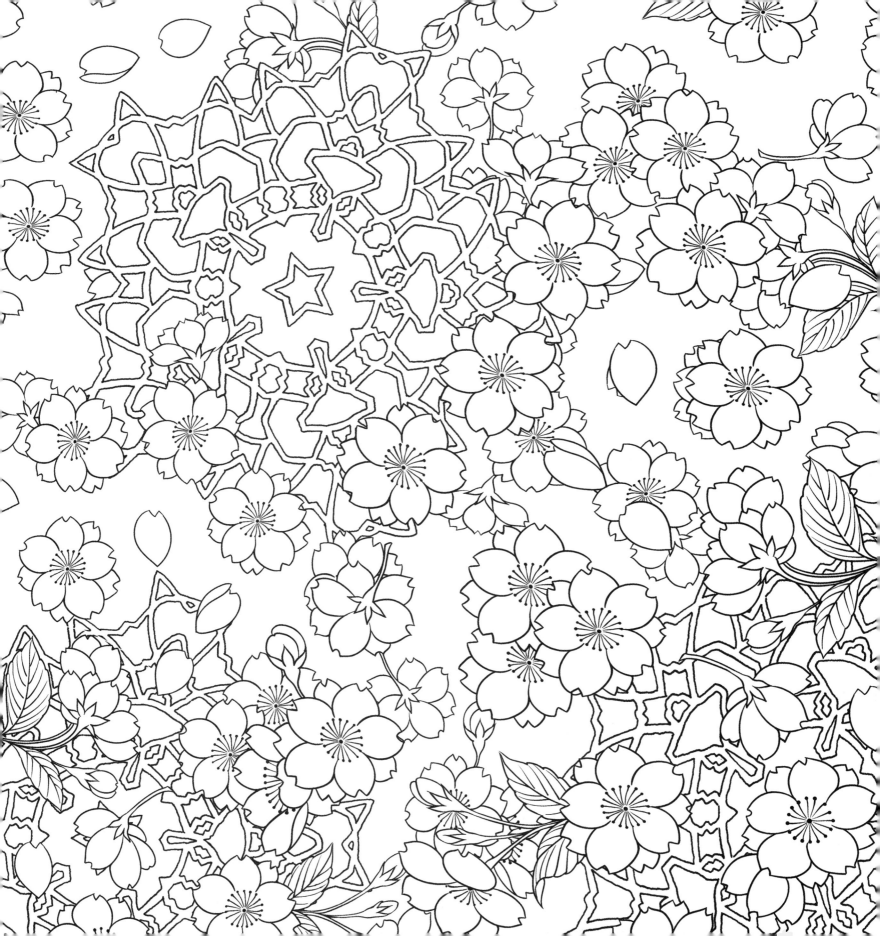

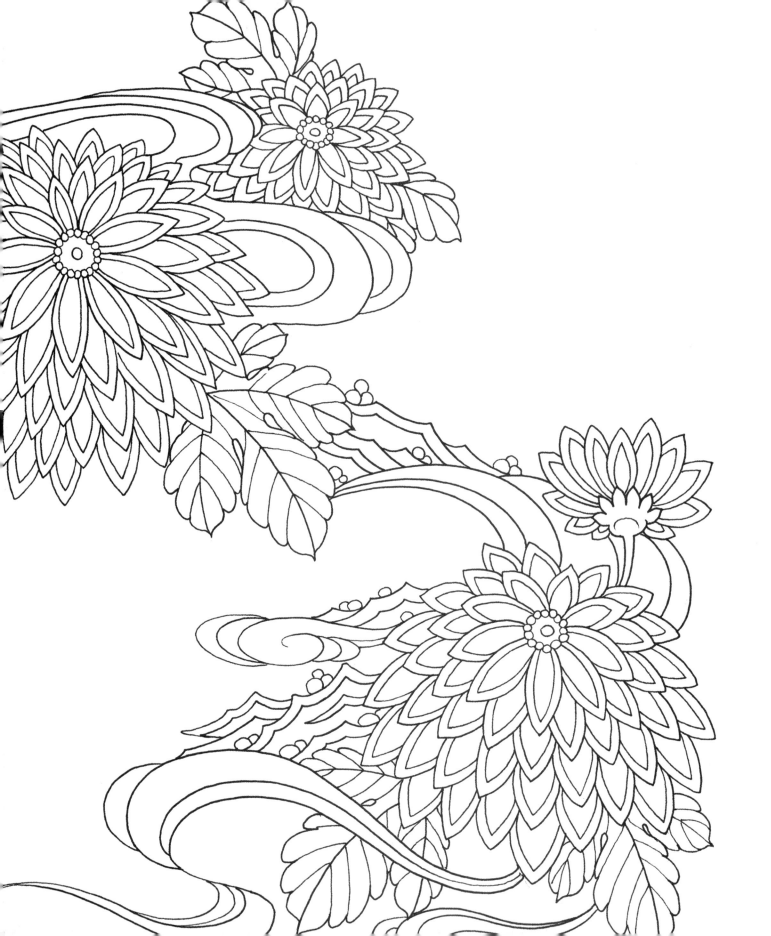

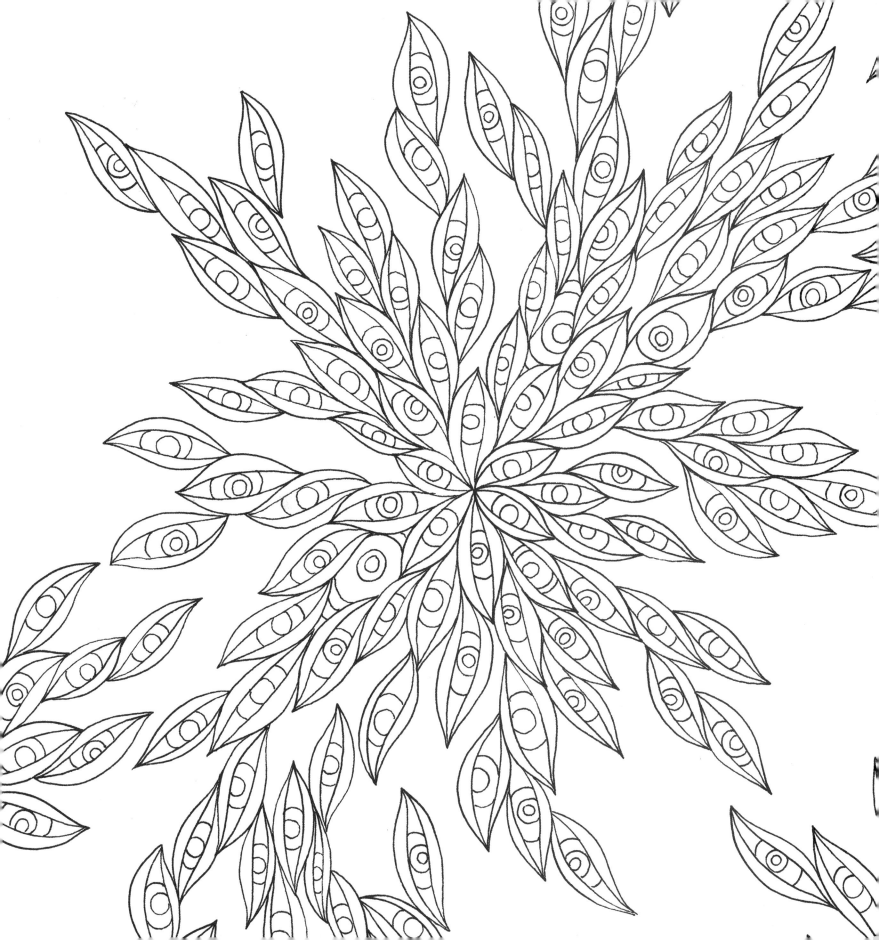

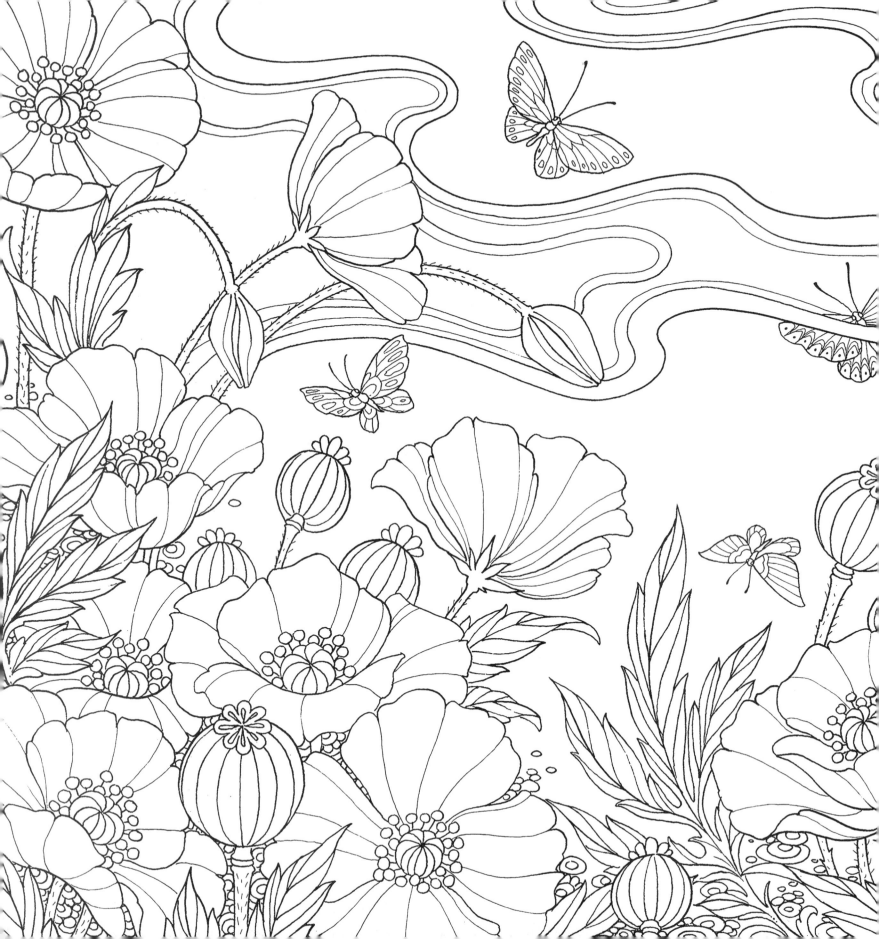

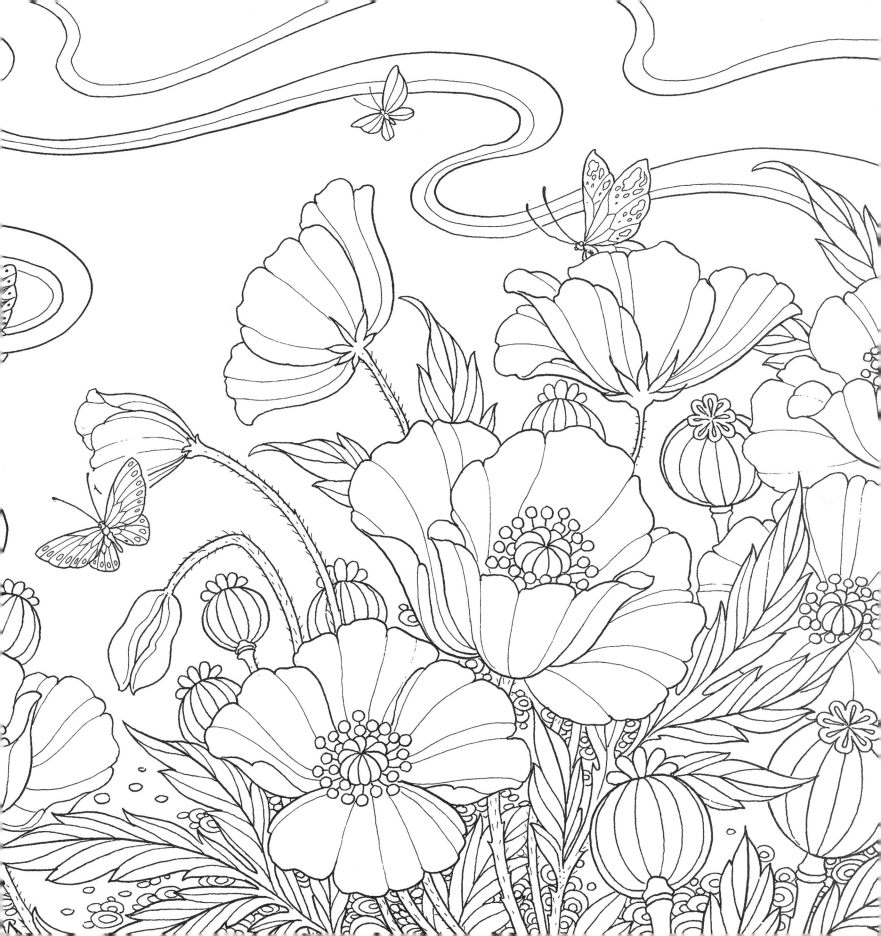

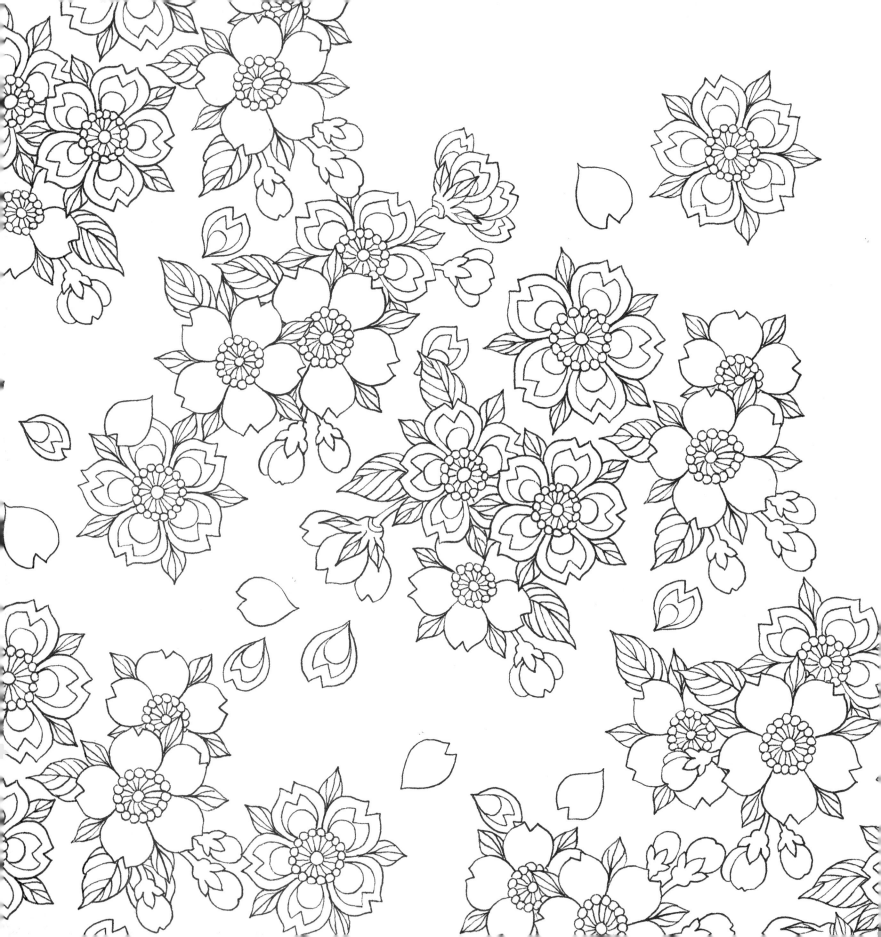

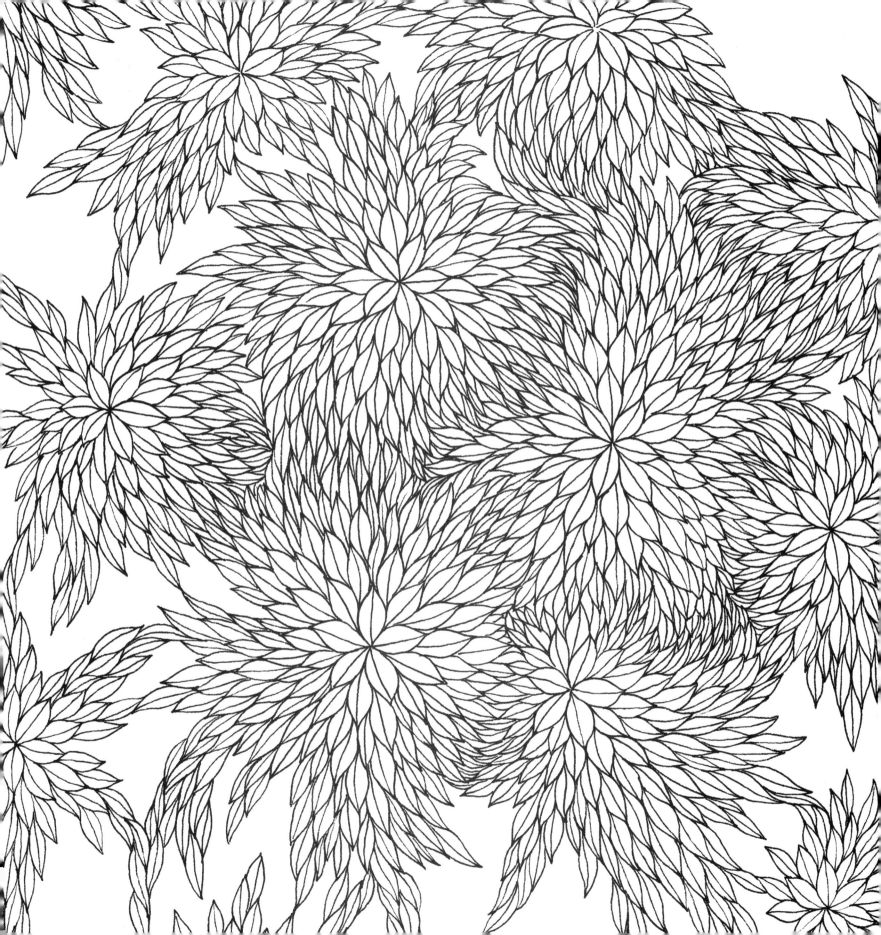

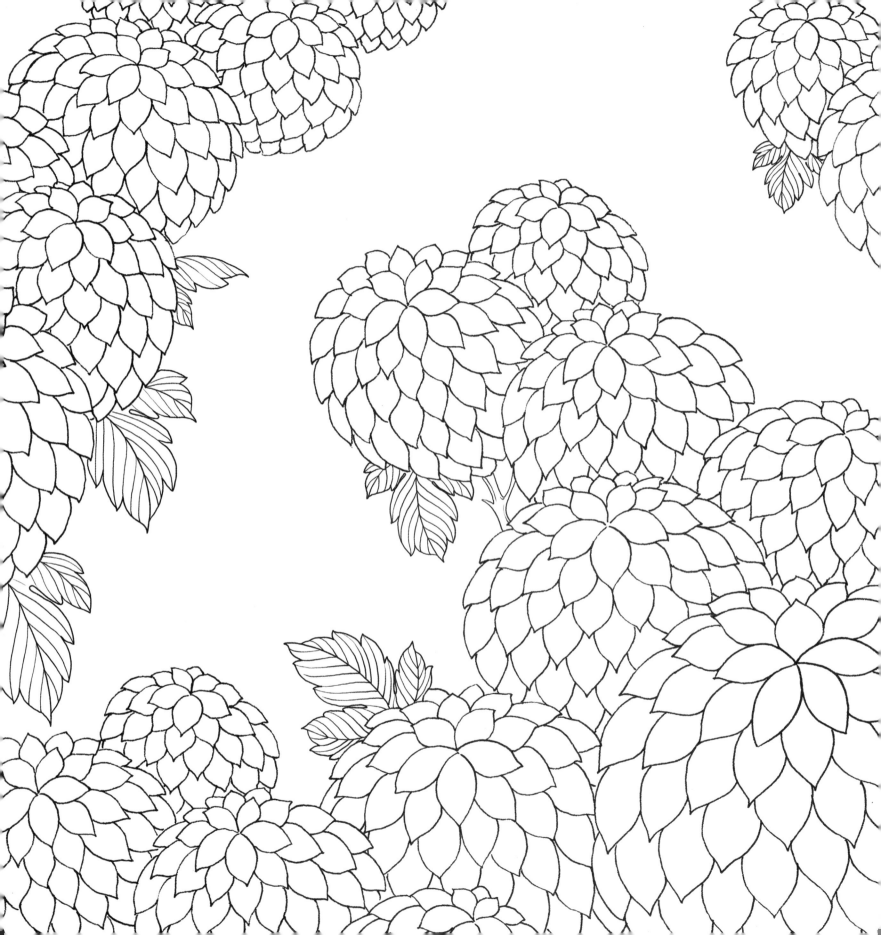

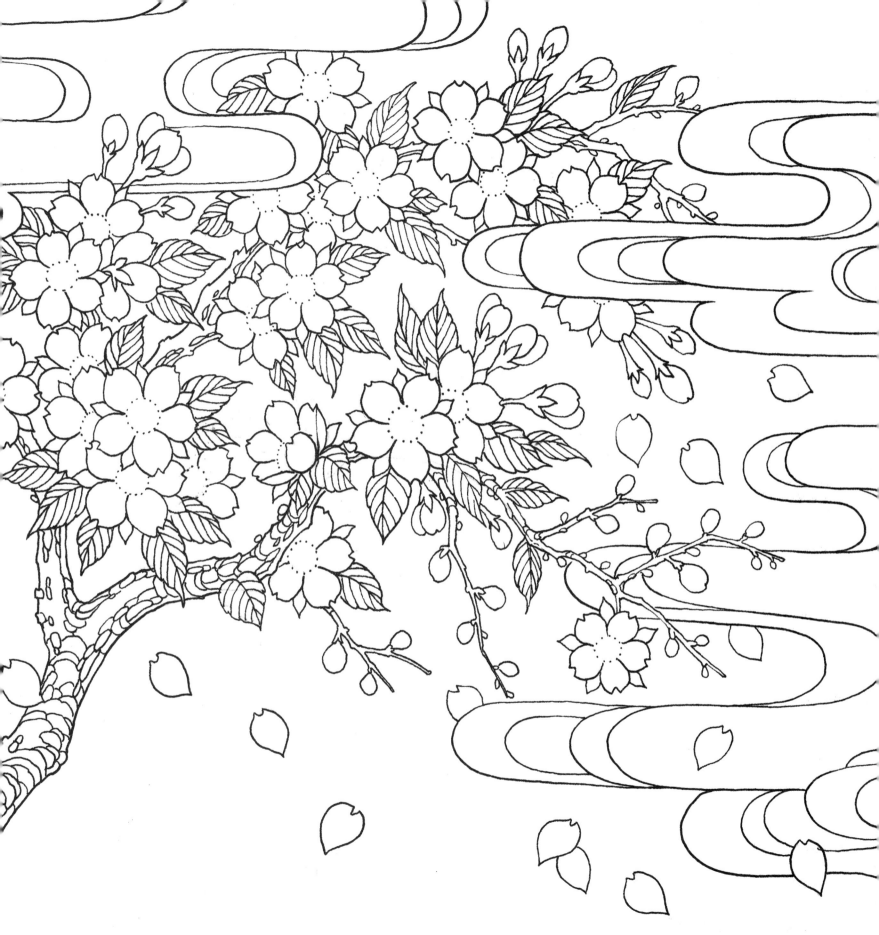

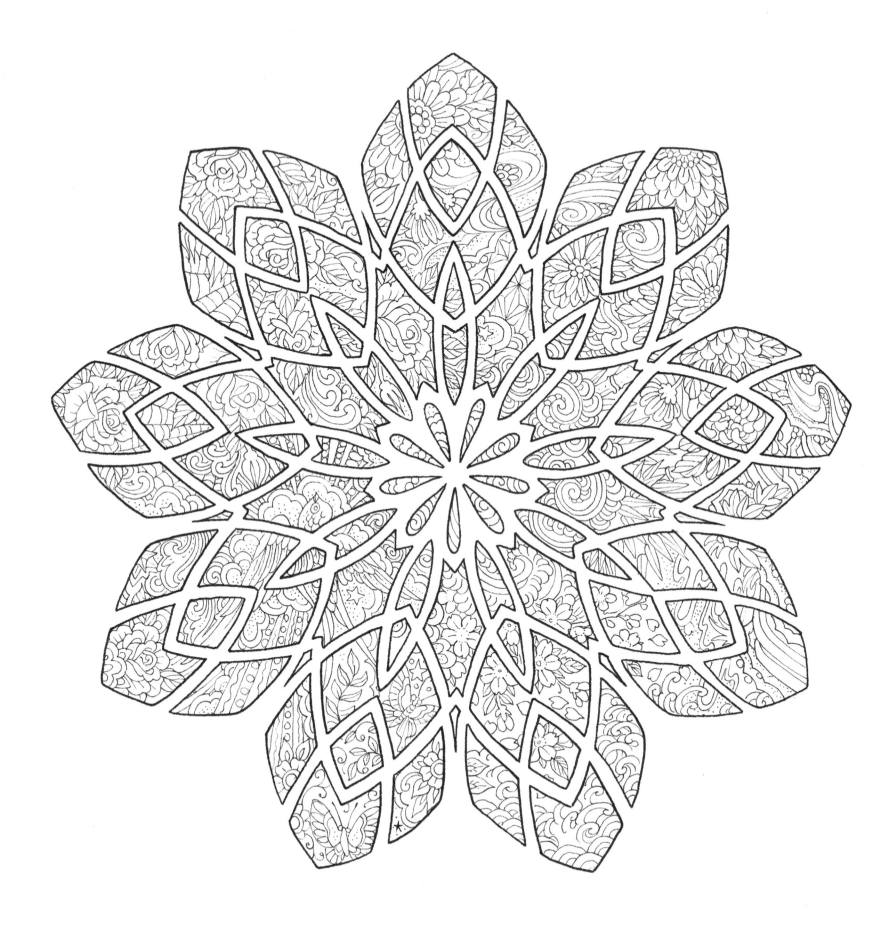

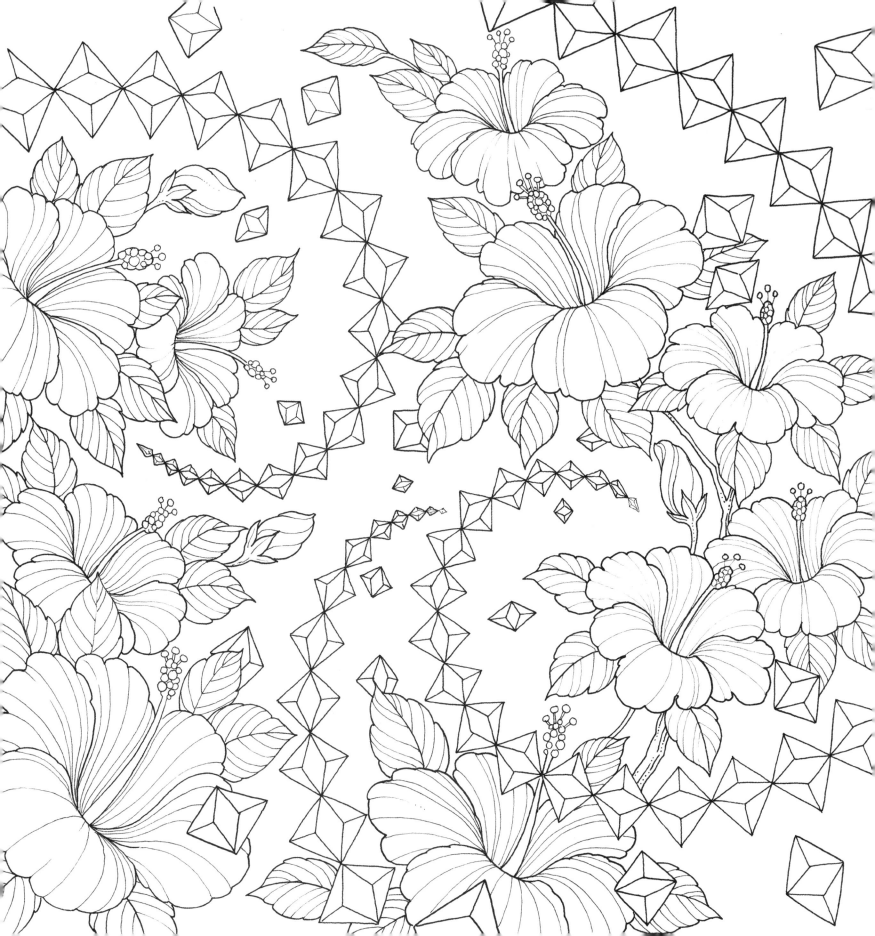

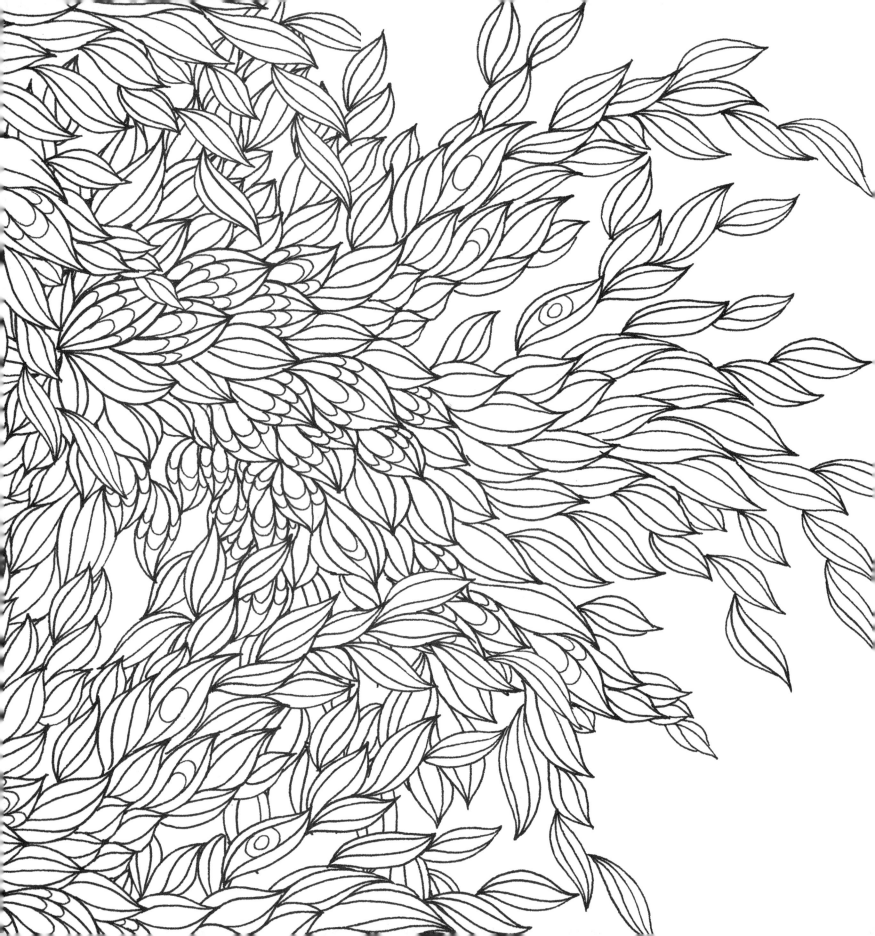

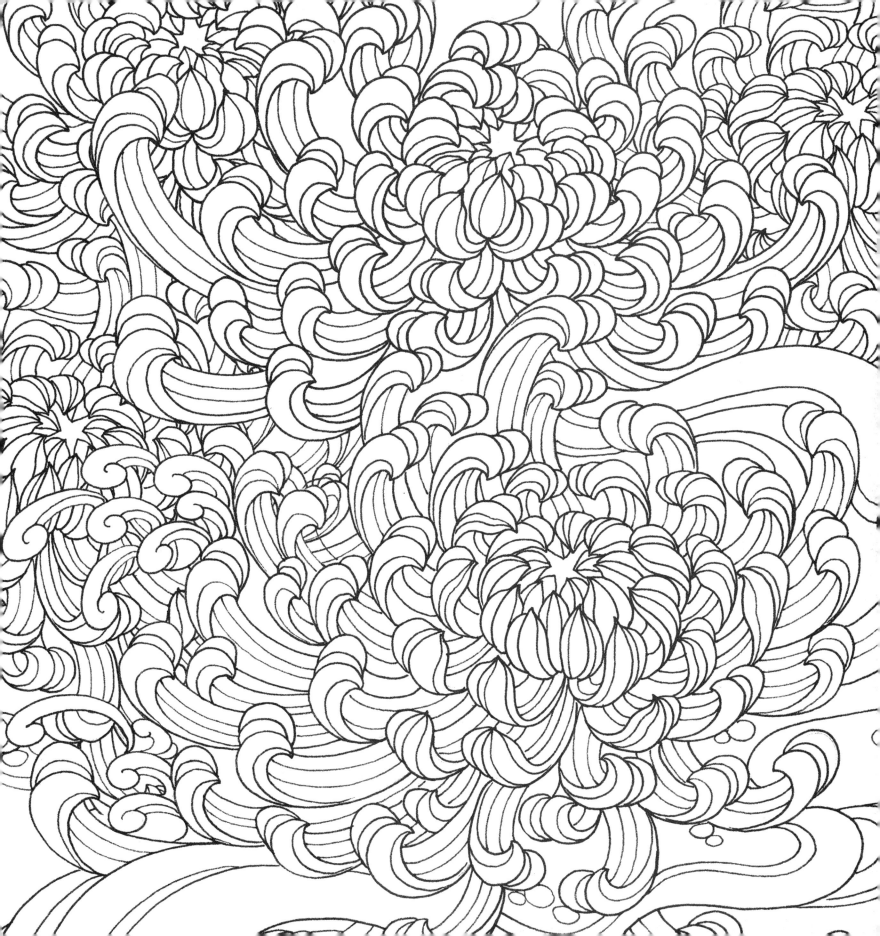

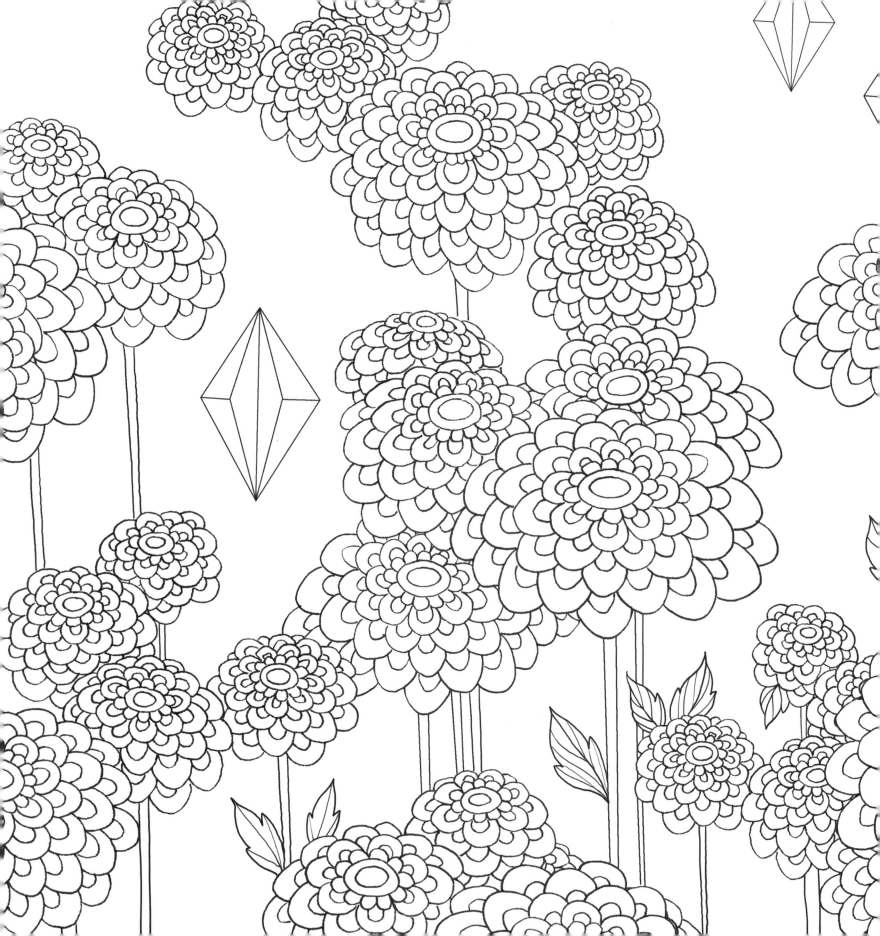

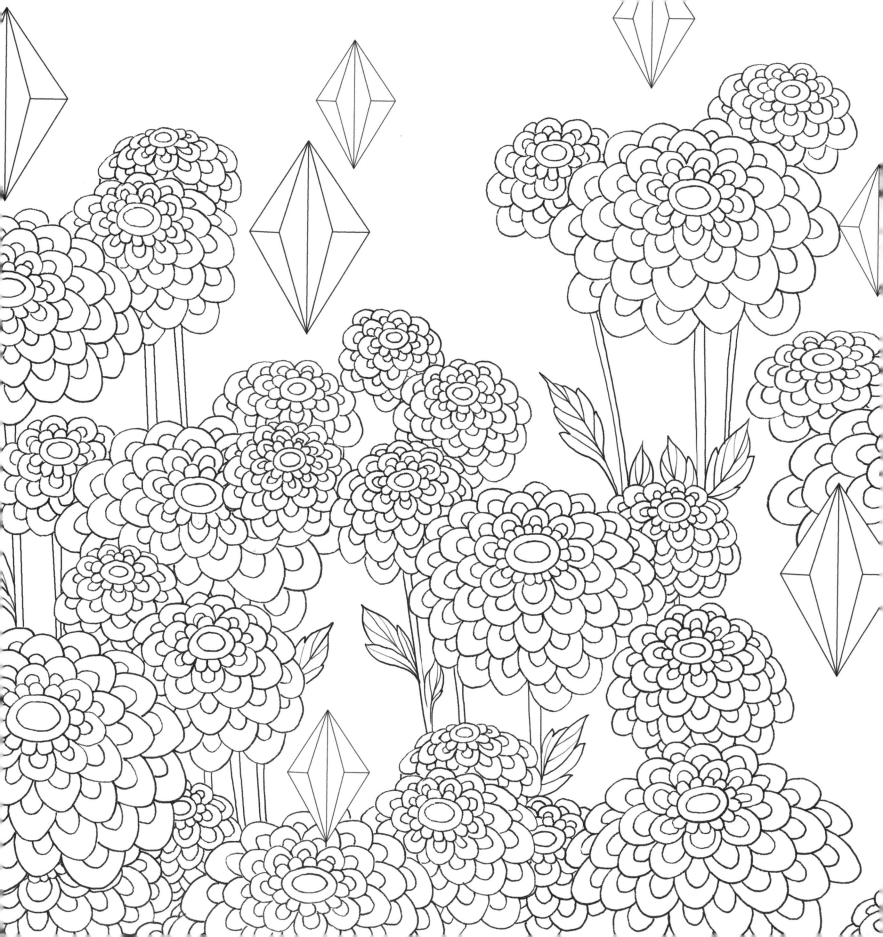

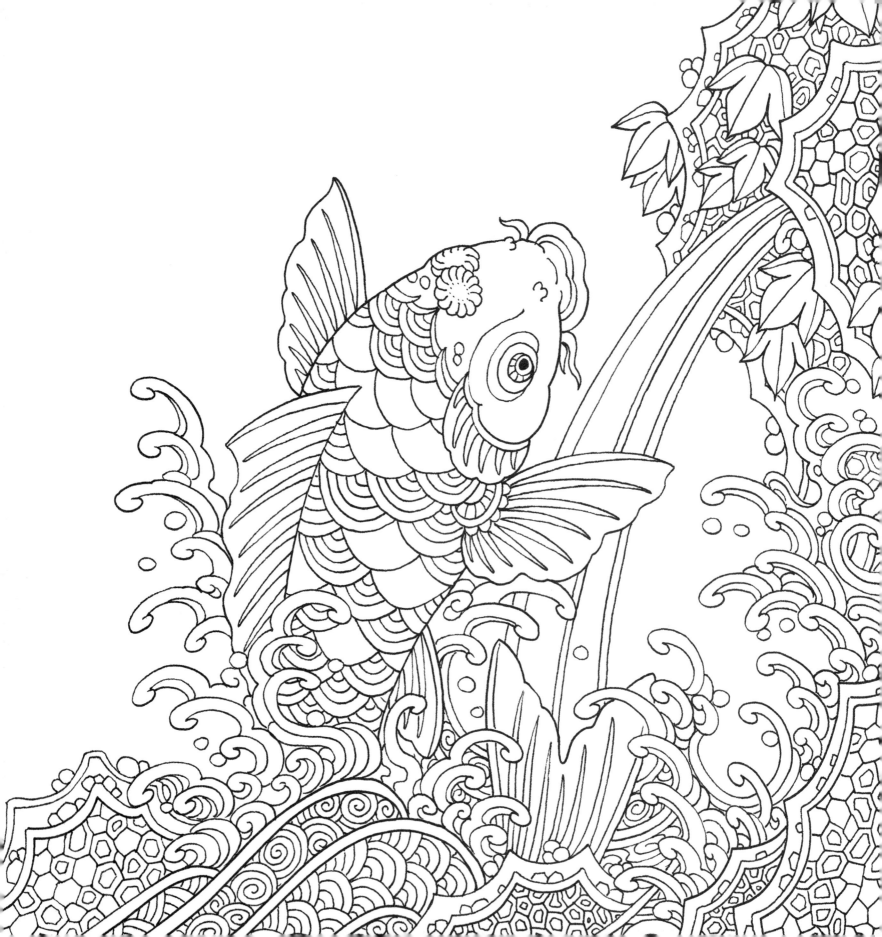

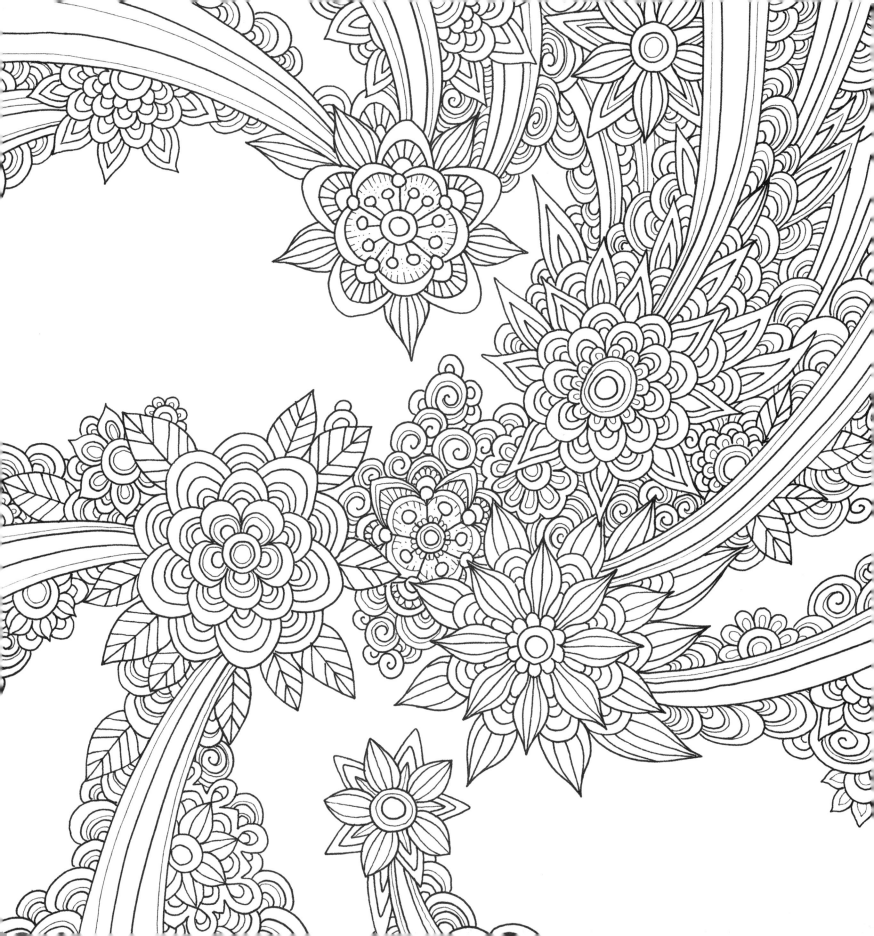

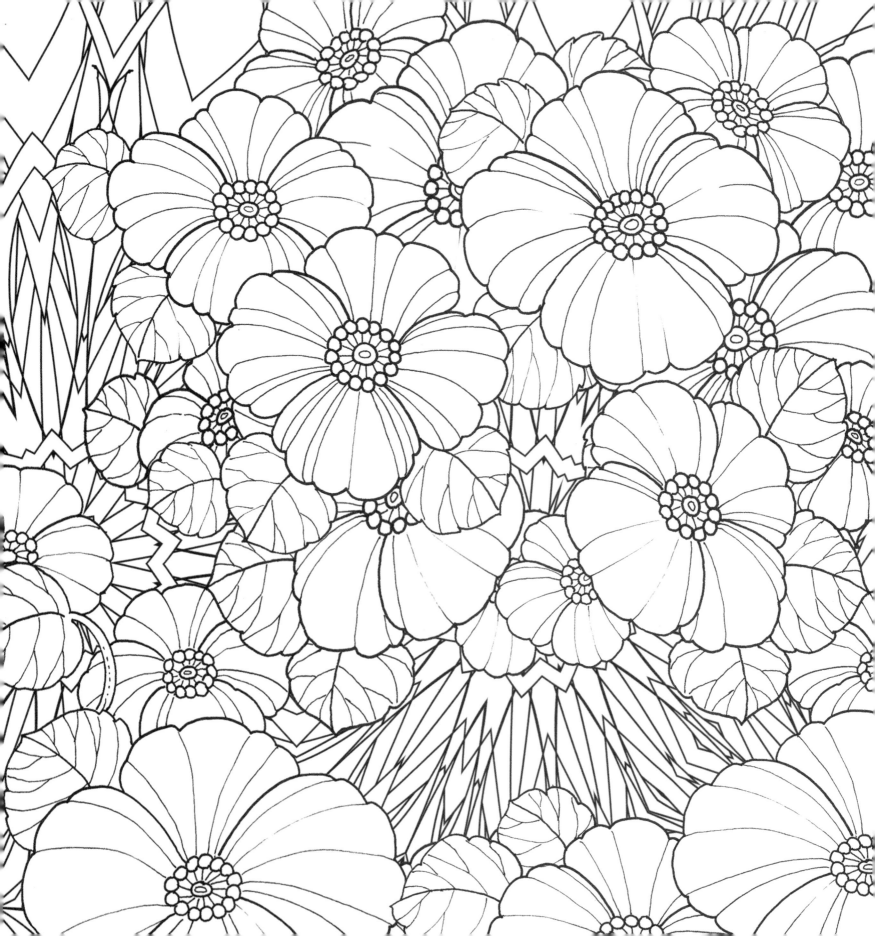

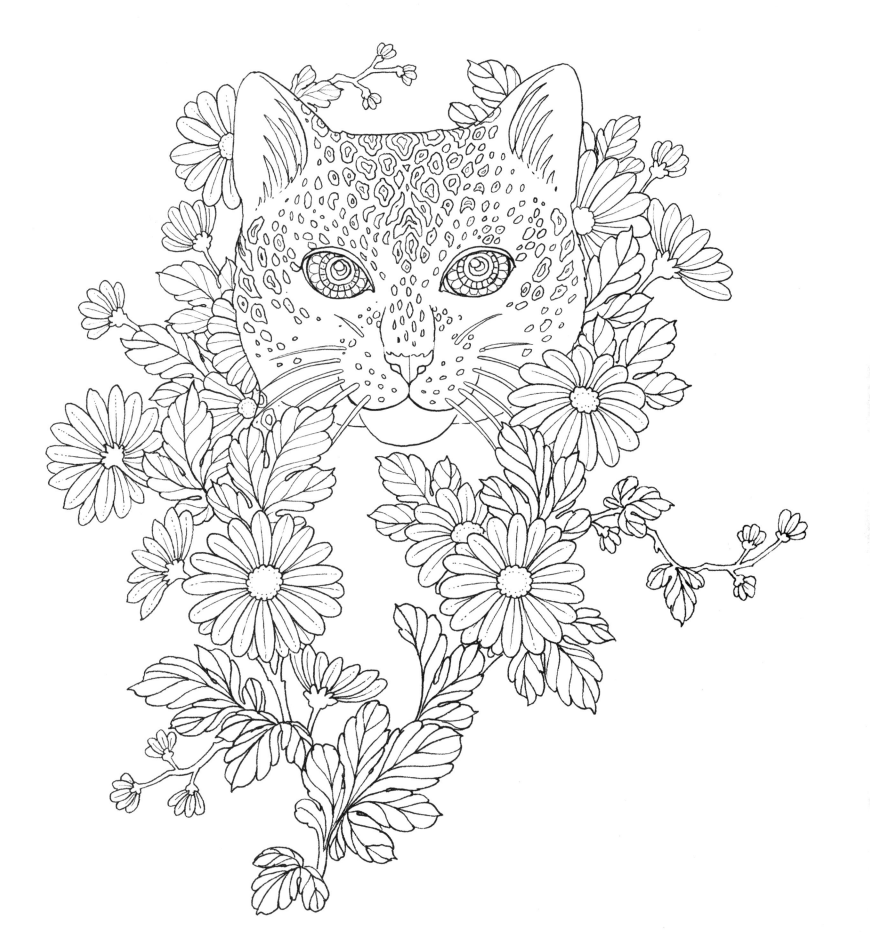

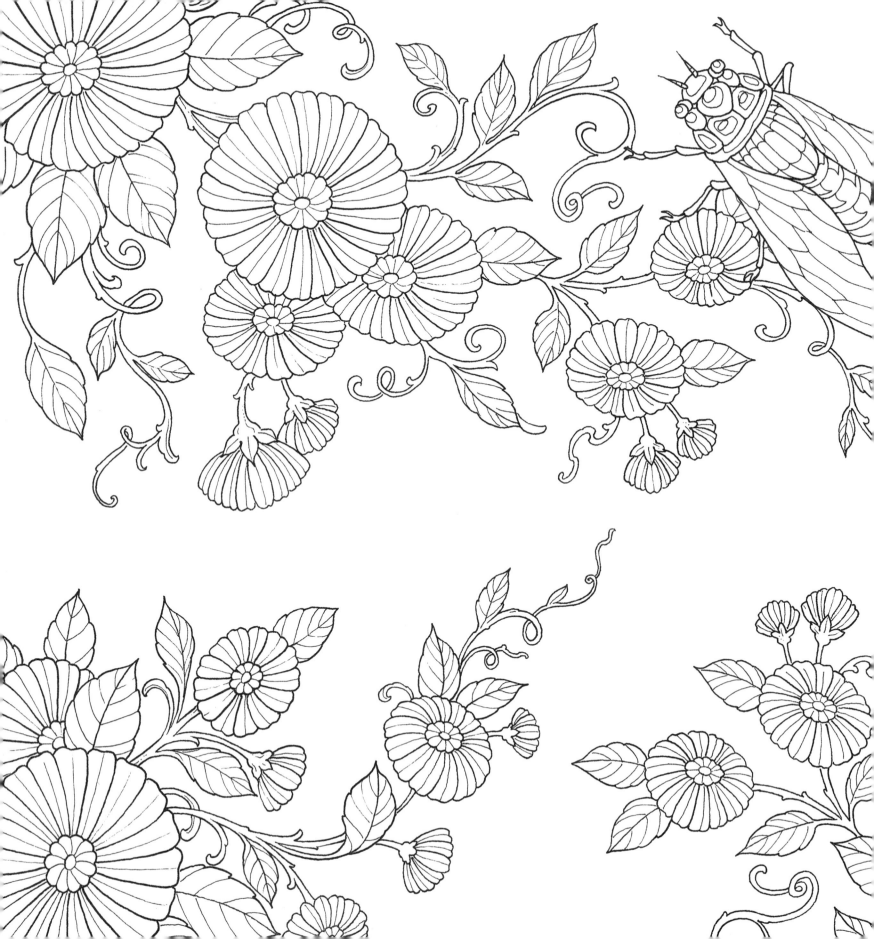

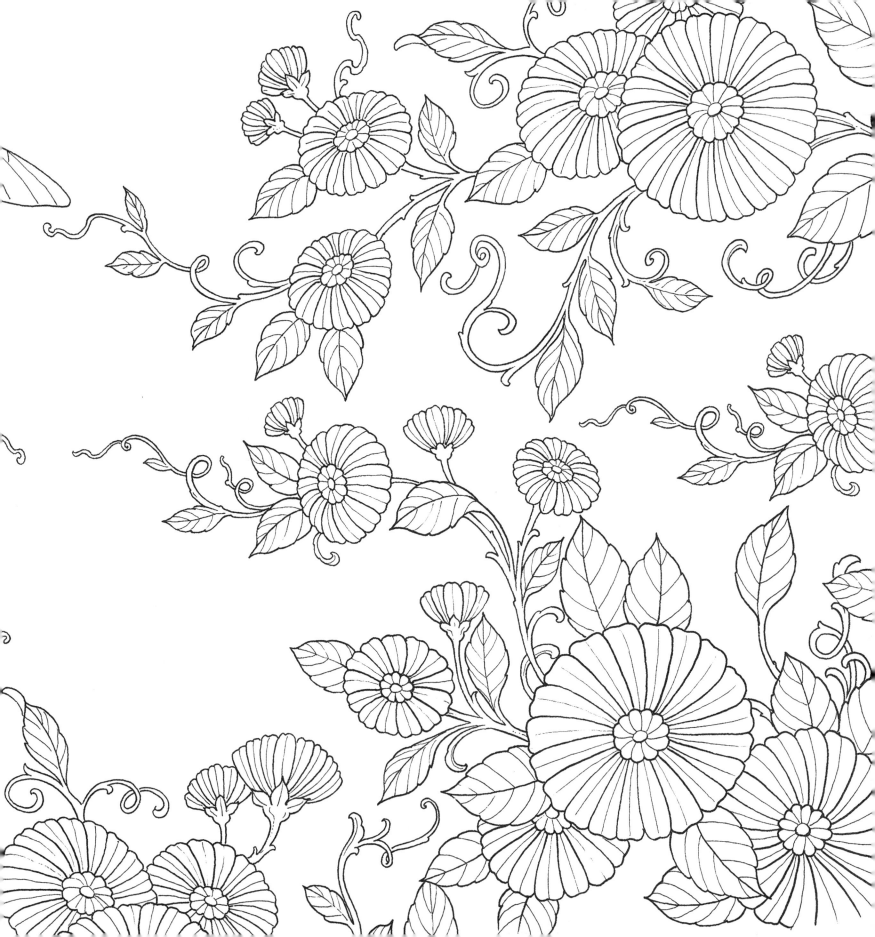

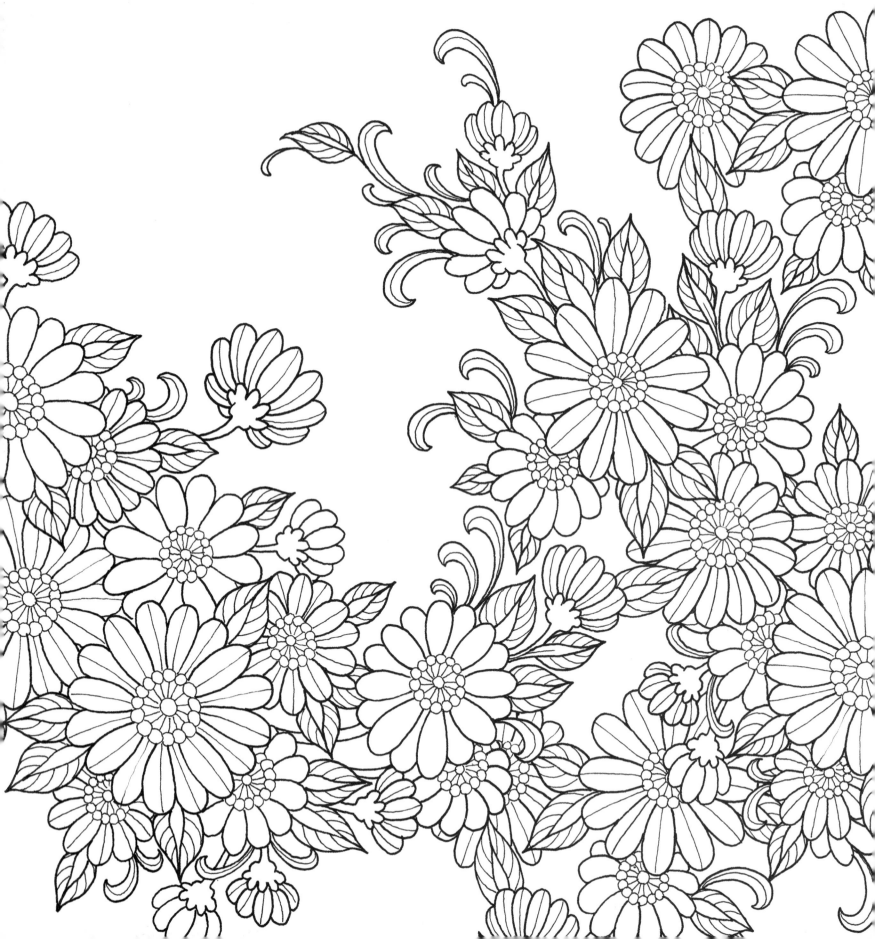

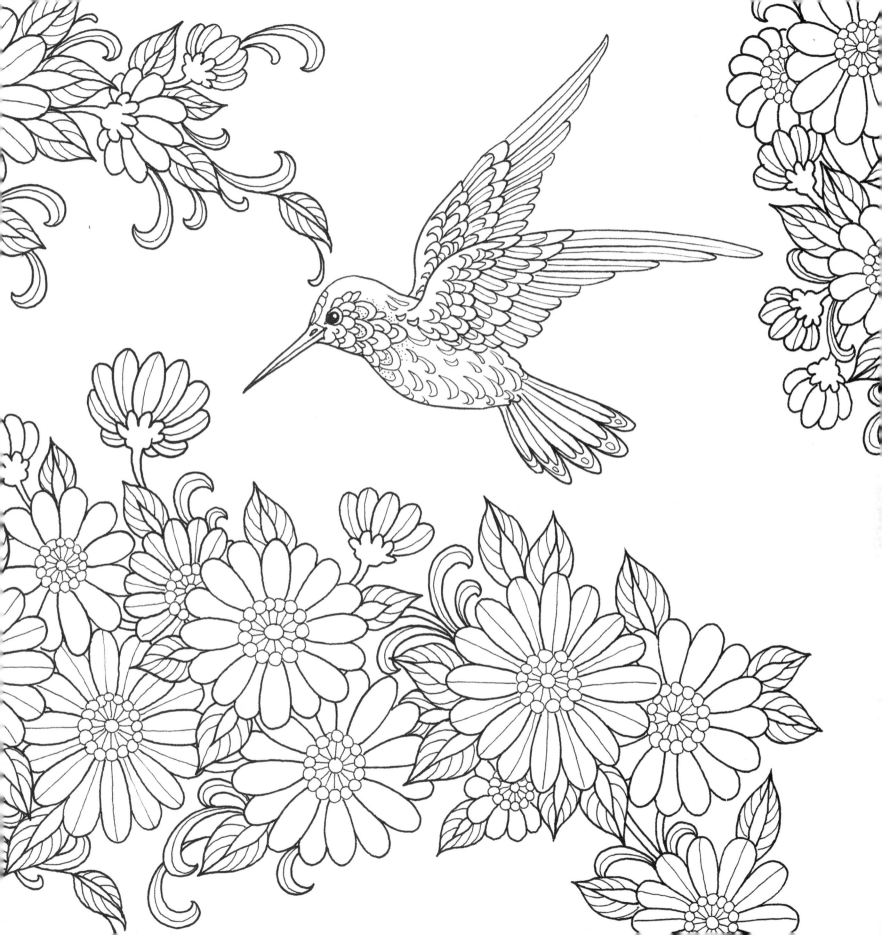

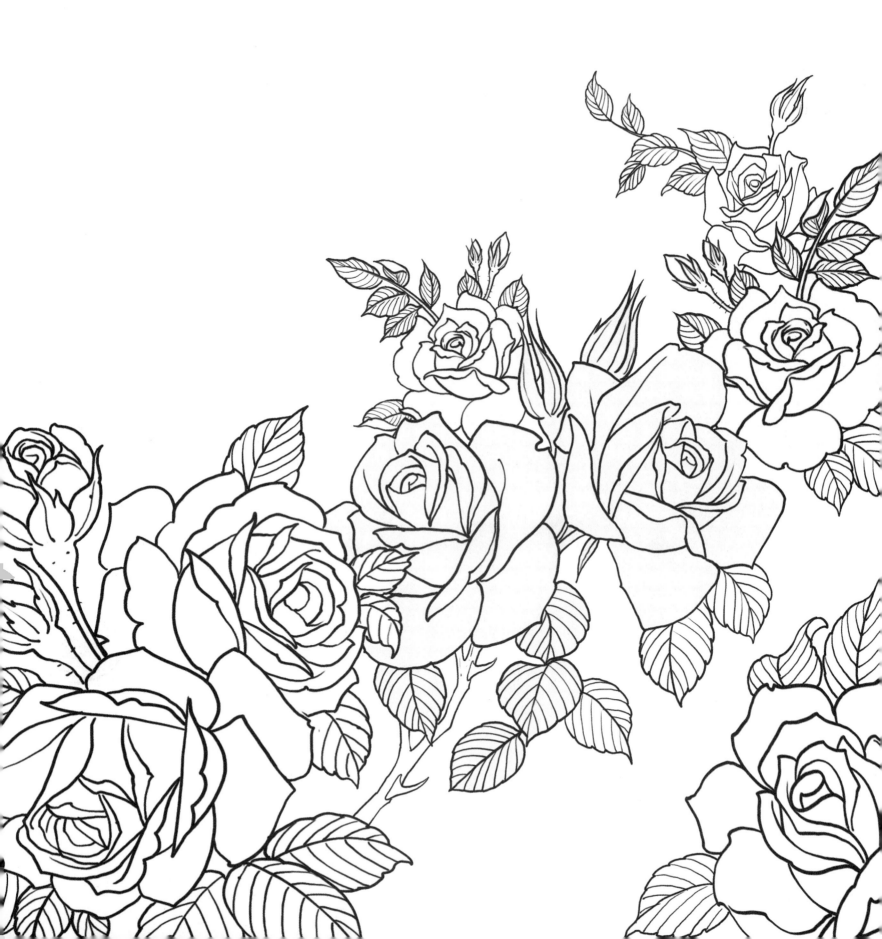

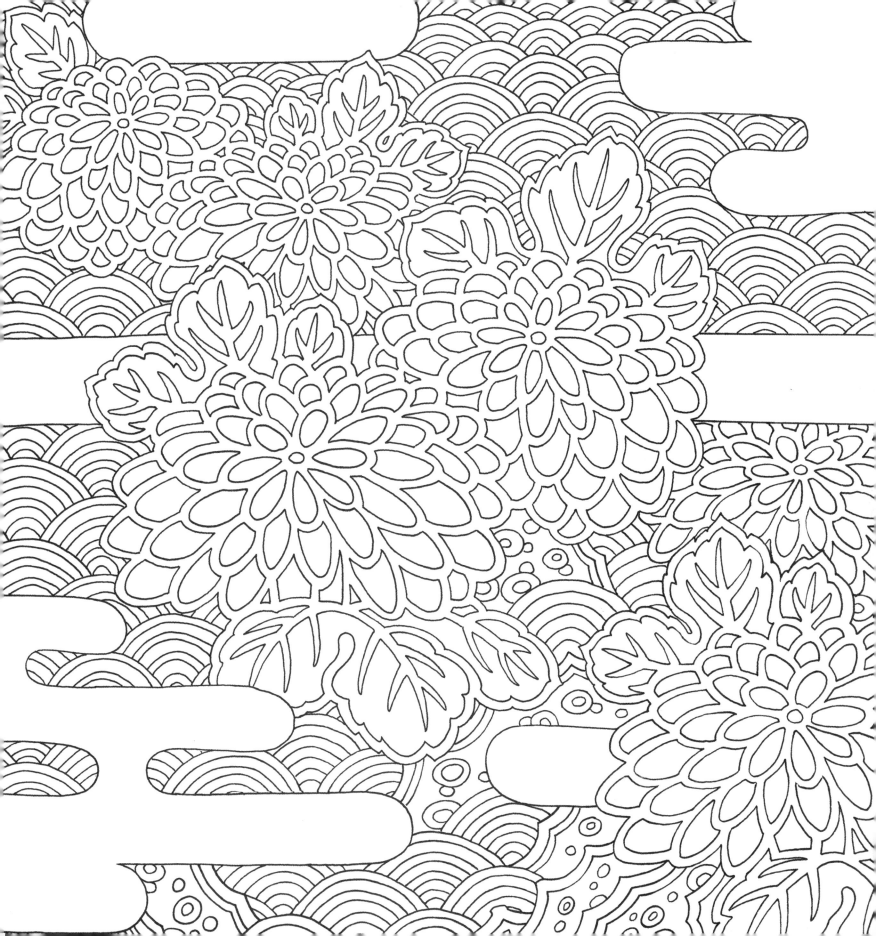

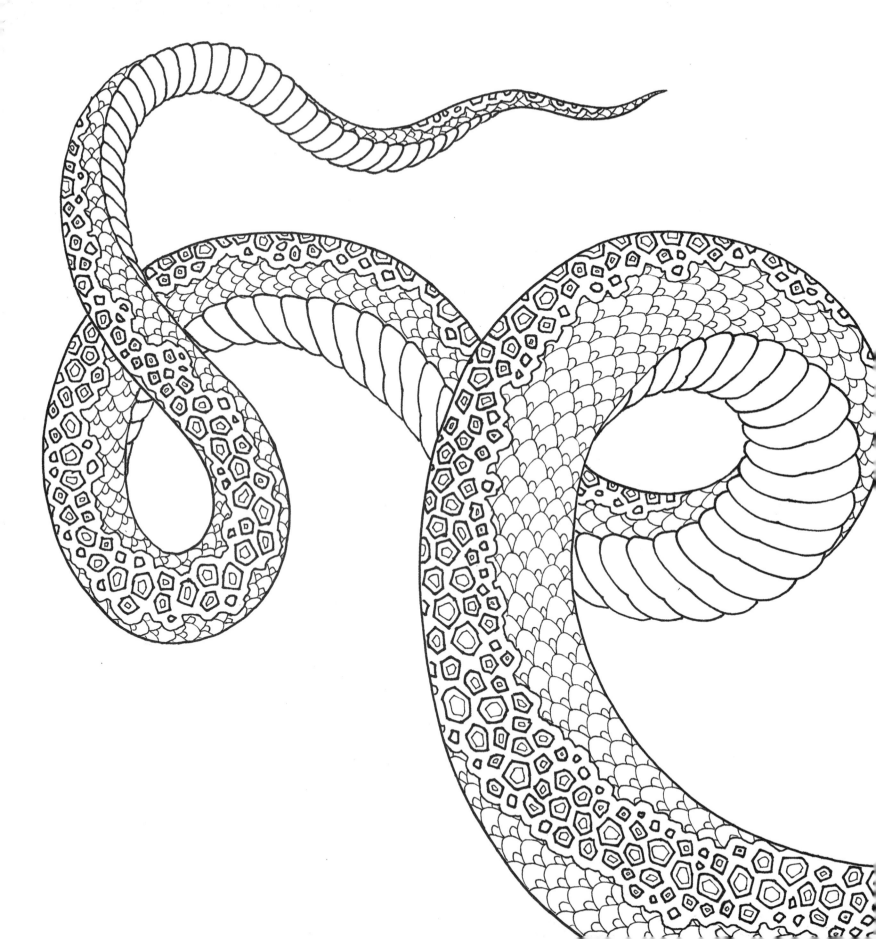

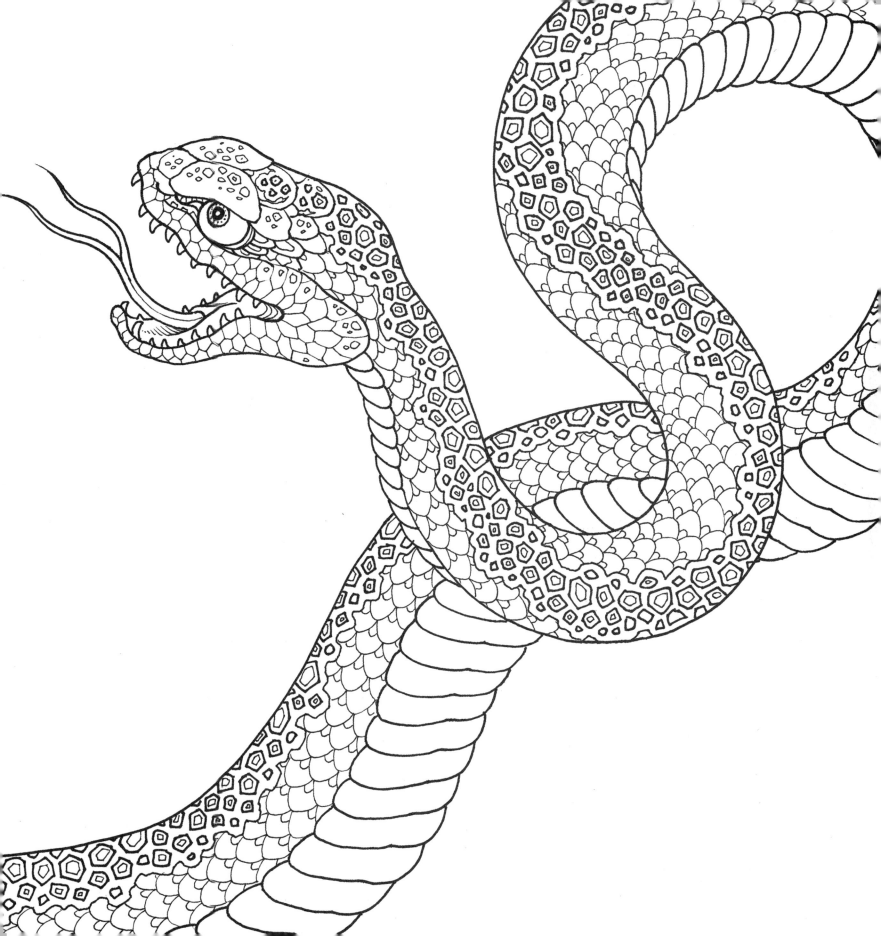

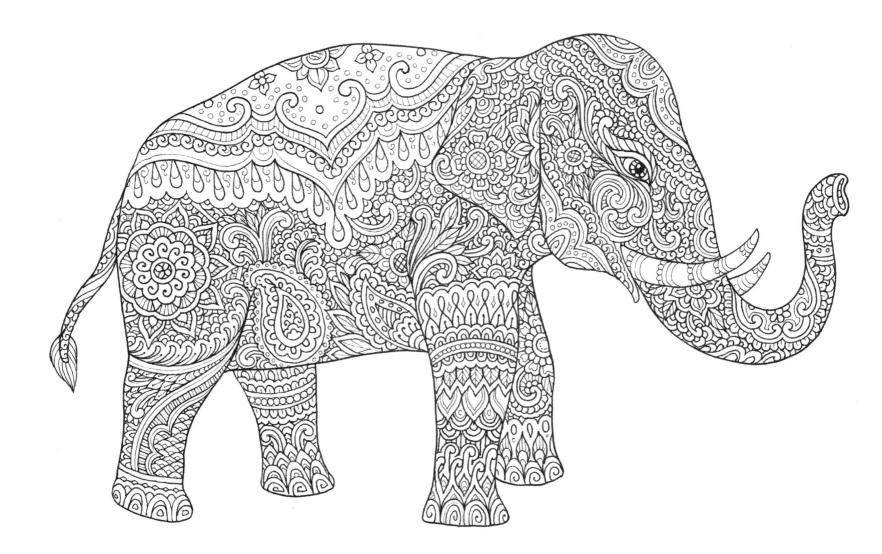

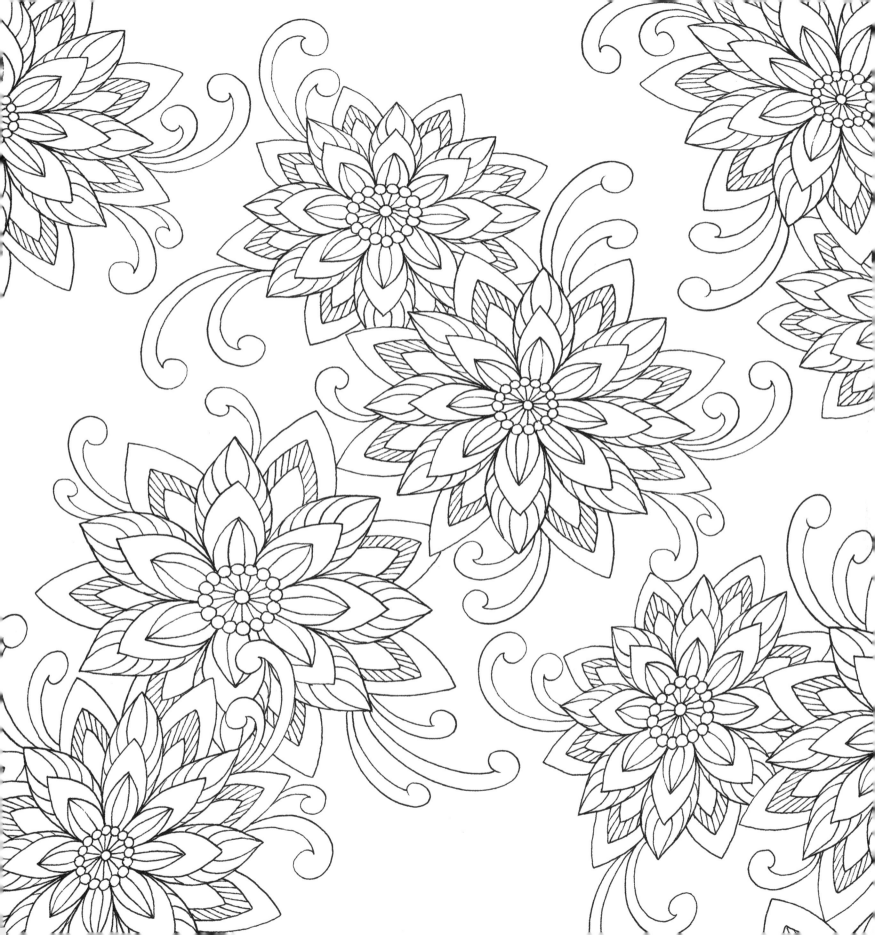

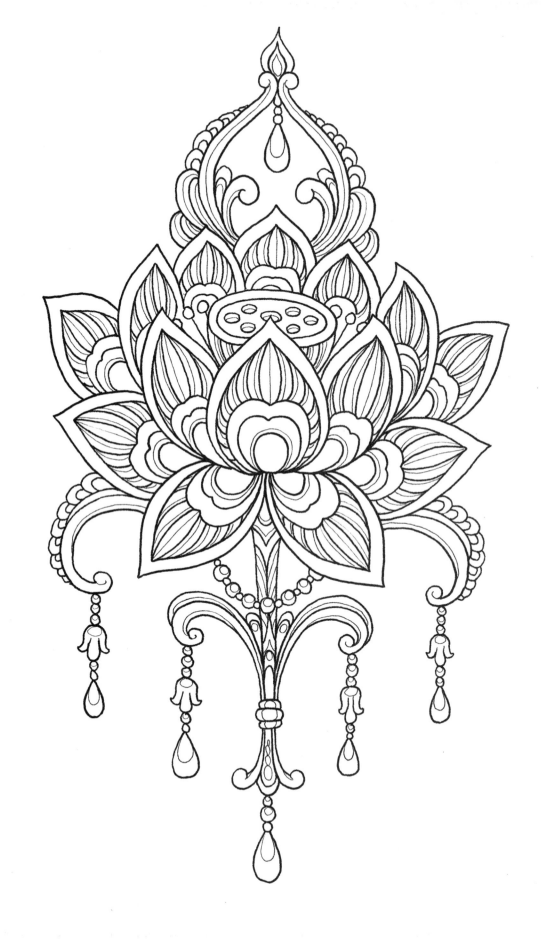

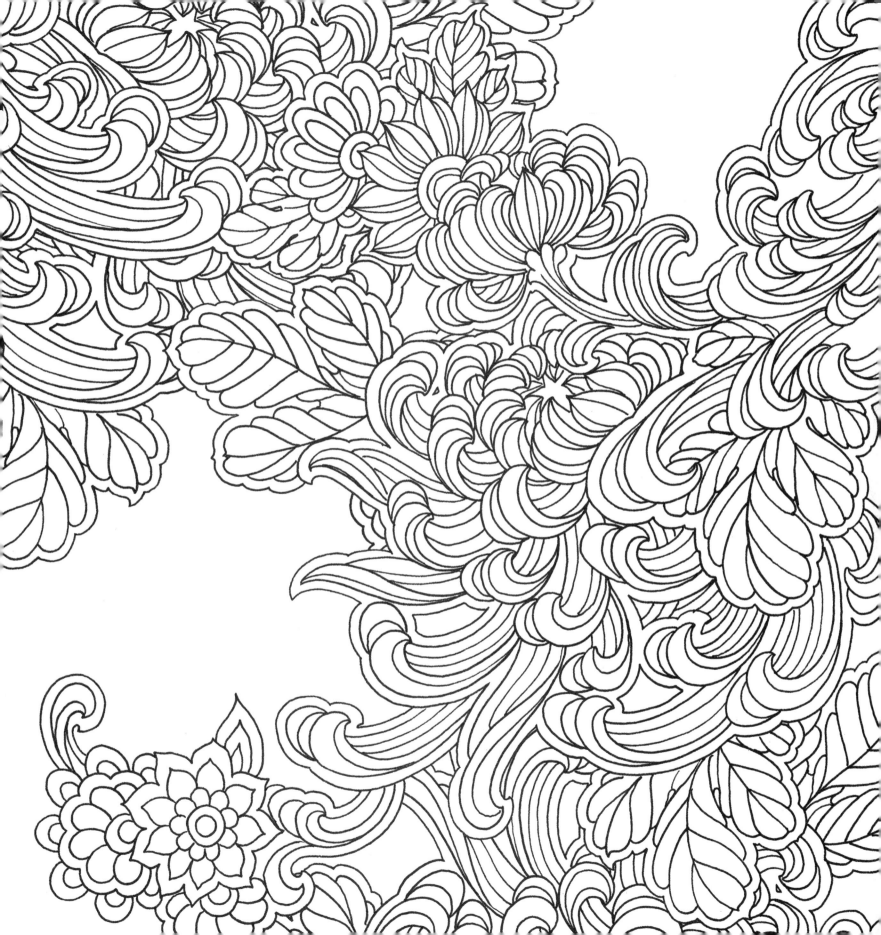

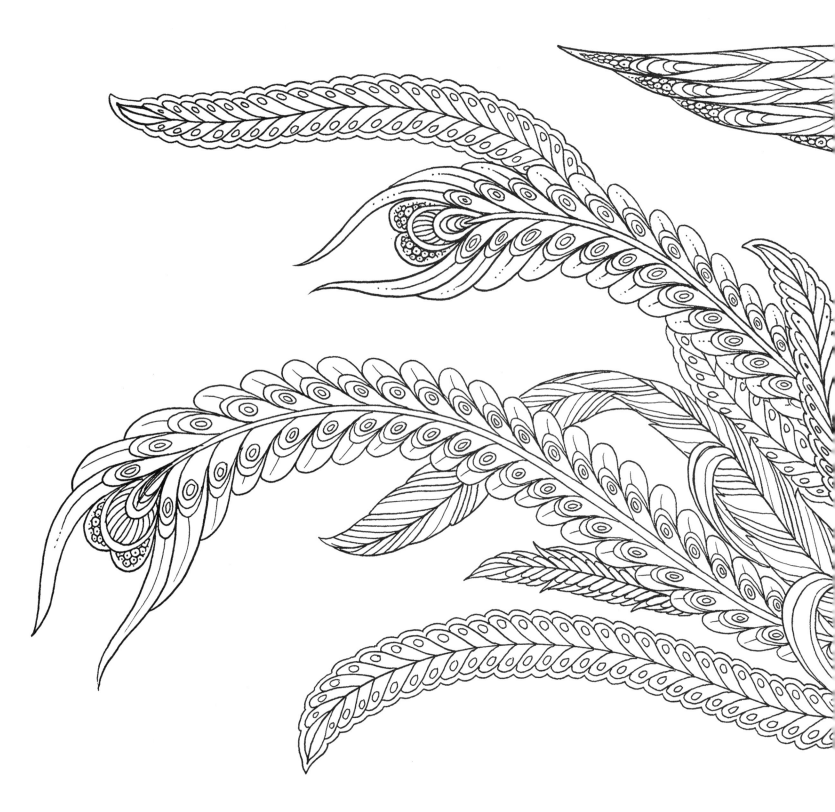

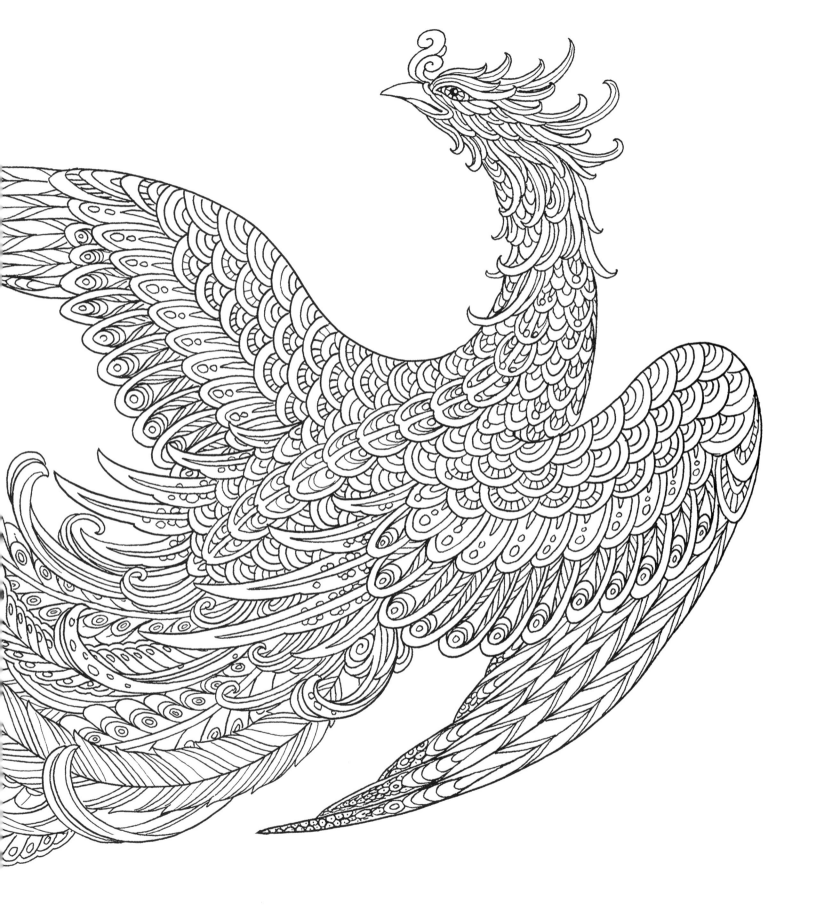

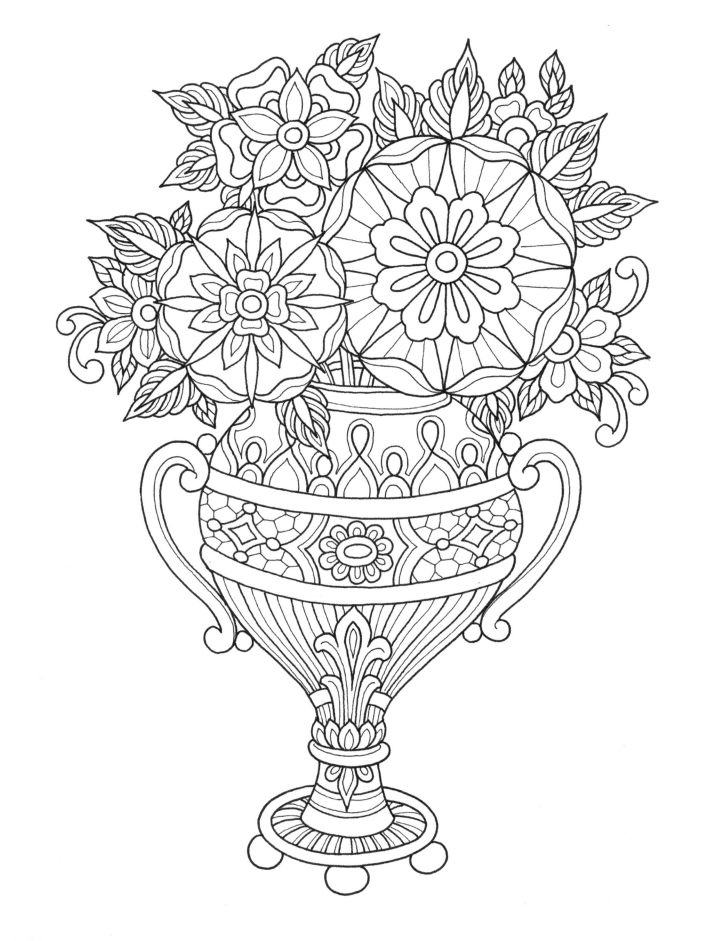

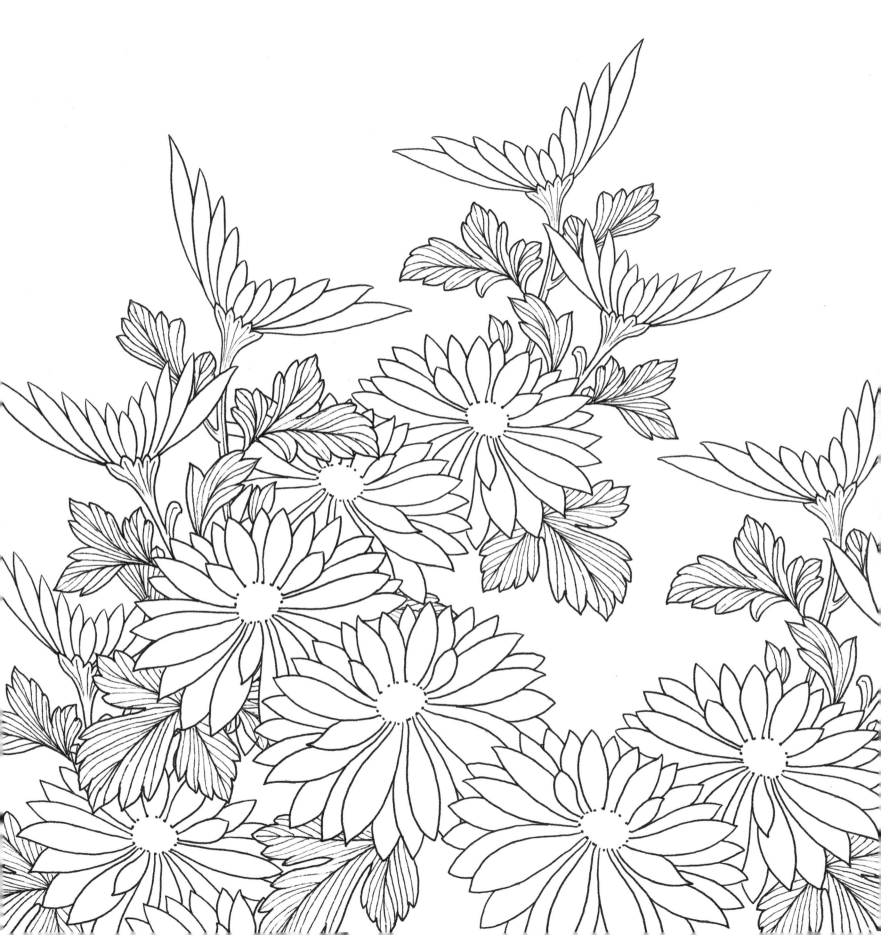

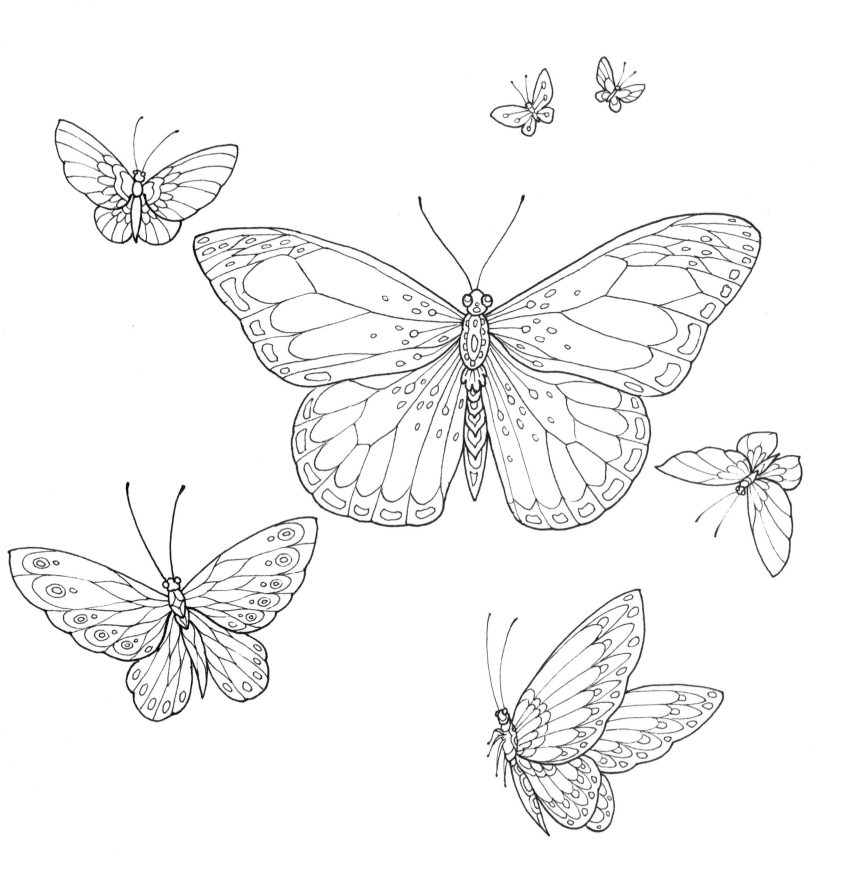

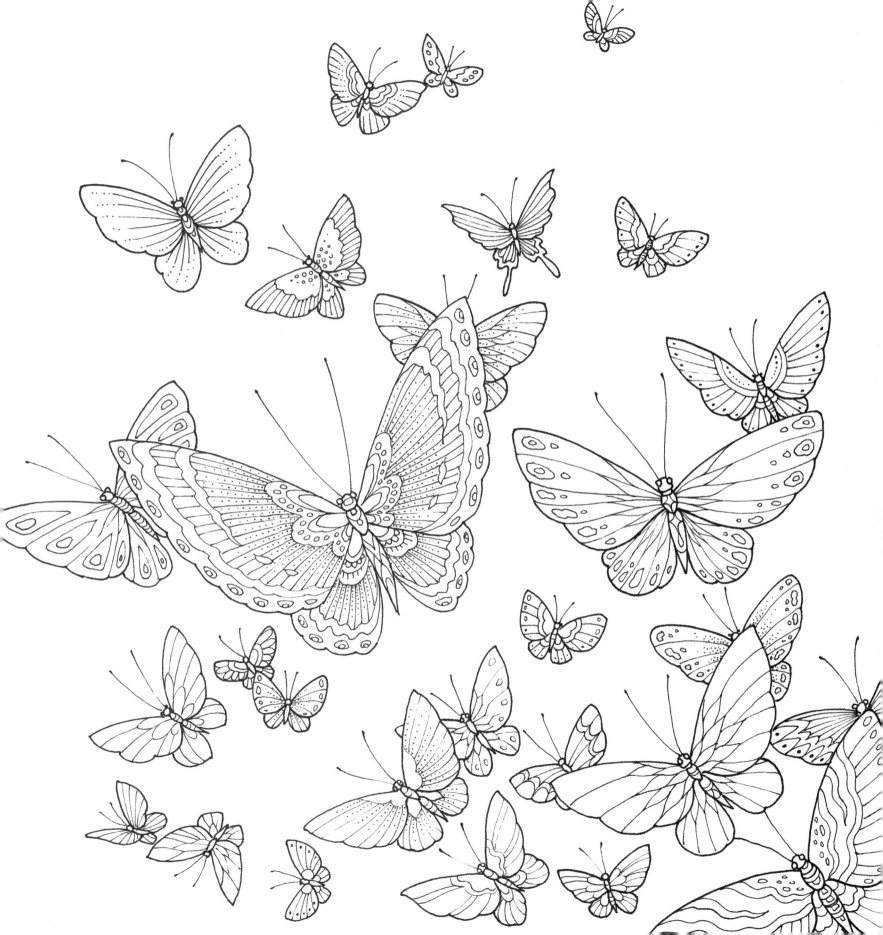

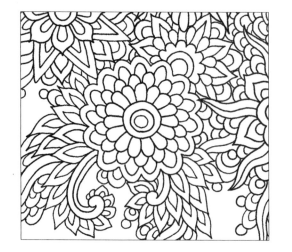

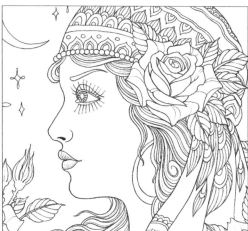

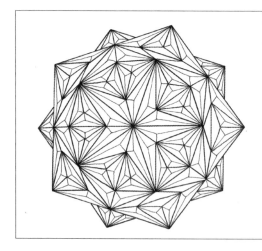

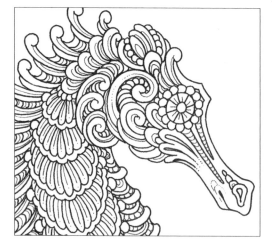

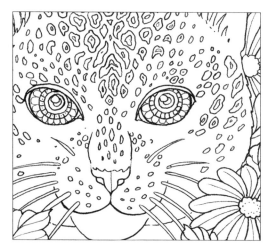

Get Creative 6

An imprint of Mixed Media Resources
161 Avenue of the Americas, New York, NY 10013

Manufactured in China

3 5 7 9 10 8 6 4 2

First Edition

CHRIS GARVER PHOTO CREDIT
Butch Hogan Photography
New York, NY
butch@butchhogan.com / www.butchhogan.com
(917) 687-8459

ABOUT THE AUTHOR

Well known and respected throughout the worldwide tattoo community, Chris Garver garnered mainstream attention after appearing as a regular on the reality-TV show *Miami Ink*. A native of Pittsburgh, PA, he attended the Pittsburgh Creative and Performing Arts High School and later, New York's School of Visual Arts. An avid traveler and aficionado of all styles of tattoos, Chris has visited and worked in such locales as Japan, Singapore, England, and the Netherlands. He currently resides in Brooklyn with his daughter.